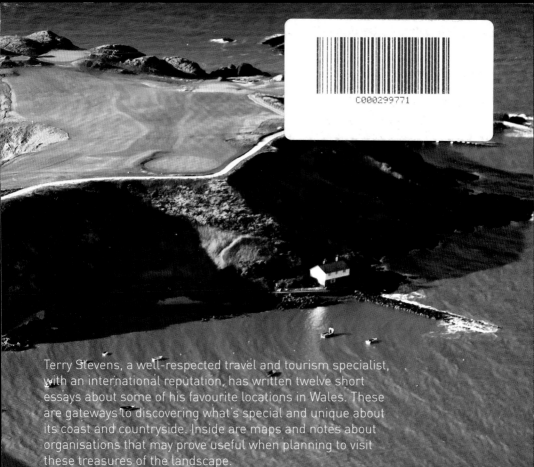

Terry Stevens, a well-respected travel and tourism specialist, with an international reputation, has written twelve short essays about some of his favourite locations in Wales. These are gateways to discovering what's special and unique about its coast and countryside. Inside are maps and notes about organisations that may prove useful when planning to visit these treasures of the landscape.

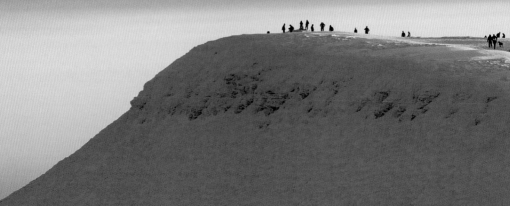

Landscape Wales published by Graffeg 2017
© Copyright Graffeg 2017
ISBN 9781910862889

Written by Terry Stevens, edited by Peter Gill
Produced by Graffeg www.graffeg.com
Graffeg Limited, 24 Stradey Park Business Centre,
Mwrwg Road, Llangennech, Llanelli,
Carmarthenshire SA14 8YP Wales UK
Tel 01554 824000 www.graffeg.com
Graffeg are hereby identified as the authors of
this work in accordance with section 77 of the
Copyrights, Designs and Patents Act 1988.

1 2 3 4 5 6 7 8 9

A CIP Catalogue record for this book is available
from the British Library.

Cover and inside cover images:
Nefyn Golf Course, Llyn Peninsula
© Harry Williams
This page: Pen y Fan, Dawn Awakening
© Drew Buckley

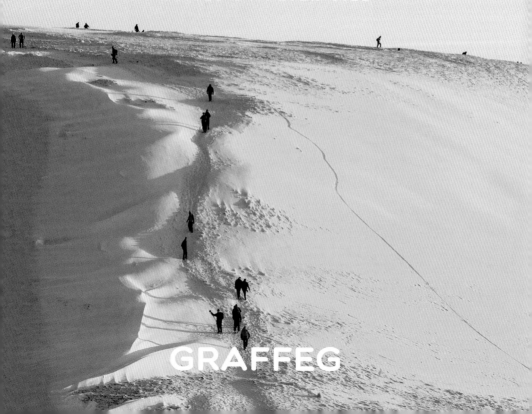

LANDSCAPE WALES

WRITTEN BY TERRY STEVENS
EDITED BY PETER GILL

GRAFFEG

CONTENTS

WEST WALES 80

SOUTH WALES 116

INTRODUCTION
TERRY STEVENS

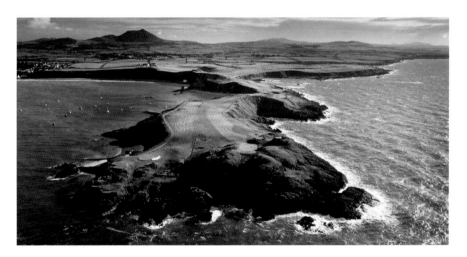

Bordered by England to the east and the sea on all other sides, this is Wales. Compact, just 170 miles, 270km, north to south and 120 miles, 200km, wide at its widest points, culturally distinct with its own language, this is a country with a population of some three million people that is, today, brimming with a new found confidence and energy.

Much of Wales is mountainous. From the high, rugged, peaks of Snowdonia in the north, through the gentler landscape of the Cambrian Mountains of mid Wales to the uplands of the Brecon Beacons in the south and the Preseli Mountains in the west; this is a landscape shaped and carved into permanence by the timeless forces of glaciers.

And yet how times have changed! Three hundred years ago the mountains and upland areas of Wales were landscapes to be avoided at all cost. Today these wild, majestic places are the reason why so many people travel to this country. These are now highly valued landscapes; great places to visit for adventure, recreation, simple enjoyment of dramatic views and for recharging our batteries ... good for the body, the mind and the soul. These special places hold a fascination within us that is deep rooted.

But there is so much more to the topography and geography of this remarkable, beautiful but, so often understated, country. The sheer diversity of the countryside, entwined with the deeply significant culture and built heritage, creates a palette of opportunities to delight the eye, exercise the body, stimulate the senses and invite further exploration and discovery.

The coastline of Wales is an ever-changing scene. It is a wavelength of rocky headlands, steep cliffs and vast estuaries; where many great rivers flow out of the mountains and disgorge into the sea, and where unrivalled stretches of great sandy beaches delight both eye and mind. Sheltered harbours, great and small ports and fishing villages underline the fact that Wales is a maritime nation. This is a country whose heritage is reflected in the ebb and flow of worldwide trade, international commerce and global exploration, and one which has a long history of welcoming visitors over many centuries.

The South Wales Valleys were synonymous with forging the Industrial Revolution in the eighteenth century. This in turn brought wealth, people and jobs, fuelling the growth of the major urban centres of south Wales and the development of Cardiff, Swansea and Newport.

However, one is never far away from the easily accessible, secluded wooded valleys, open moorlands or carefully tended farmland of rural west Wales and the borderlands of the east.

This is a landscape full of internationally important wildlife, heritage and natural features. There are three national parks: Snowdonia, Brecon Beacons and the Pembrokeshire Coast, and seemingly countless ancient monuments and castles. It is a landscape whose character has been crafted by the very people who have lived and continue to work it. The sense of place is palpable; the cultural influences ever present. A land of myths, legends and folk traditions, it is also a great place to visit.

Tourism is really important to the economy of Wales. Each year a 'croeso' a welcome, is extended to visitors from all over the world who are attracted by the beauty, heritage and culture of Wales. Increasingly, visitors are recognising the breadth of adventure that is possible in this landscape, from adrenaline-inducing activities that embrace the extreme, to the less energetic, more aesthetic, things to do.

Photography has, of course, been the primary source of imagery to present, represent and promote Wales. These images shape our perceptions and our expectations of the feel, character, personality and sense of place. All too often they present a passive scene that conforms to a conditioned view of a safe, stable and reliable countryside whose frailties are rarely exposed to the public gaze.

Yet behind these stereotypical portrayals are dynamic environments and marginal communities facing severe challenges in terms of competing, sometimes conflicting, land uses. They face the need for biodiversity, conservation and, increasingly, the need for the land to function as a space for tourism and recreation. Sentimentality in terms of the ability of the landscape to inspire and quicken the sense of wonder is constantly being tempered by the economic realities of maintaining viable local communities.

These are enduring landscapes, but to ensure their long-term relevance to the majority of us we must give them the respect and the resources they deserve – especially when out enjoying the countryside. There are rules to observe and care to be taken.

Through the most democratic and accessible form of art, photography, this book challenges its reader to recognise fully the importance of the landscape of Wales to us all, individually and collectively. The images reflect the dynamics of the raw elements: the impact of people, geology, topography, of wind and weather on our

emotions. Underpinning the experiences you will derive from this discourse is the sheer power of the photography. In the words of Sandra Phillips, the former curator of the San Francisco Museum of Modern Art, "It is only in photography are we still able to find astonishing surprises and the most eloquent of marvels".

The selection of twelve special places to write about was especially challenging. I have sought to achieve a balance in the final list that includes locations from across Wales – north, south, east and west, but also having representation from the uplands and lowlands, the coast and the interior, the urban and the rural, the natural and the man-made. Many of the places I have selected are iconic, well known, often-used places that you may think you know. Others are lesser known but have no less significance and are of course, worth a visit.

Unashamedly, all the places selected are personally significant and relevant, but, I hope, their history has deeper resonance with themes and topics that make the story of Wales. Woven into the narrative about each of the twelve locations is something about the topography, the geology, the heritage and the culture that gives each

its strong sense of place. Then, I have tried to tie all the places together with threads that are common to all – a shared historical figure, a cultural connection or a geographical link.

It is, of course, impossible to do justice to the full array of landscapes and places in this book. The aim is to give the reader a flavour of the splendour of this remarkable land. For those of you who live here or who are familiar with Wales, perhaps this book will give you some fresh insights or encourage you to explore further. For those who are less familiar with the country hope that these images and words will help you understand and encourage you to enjoy Wales even more.

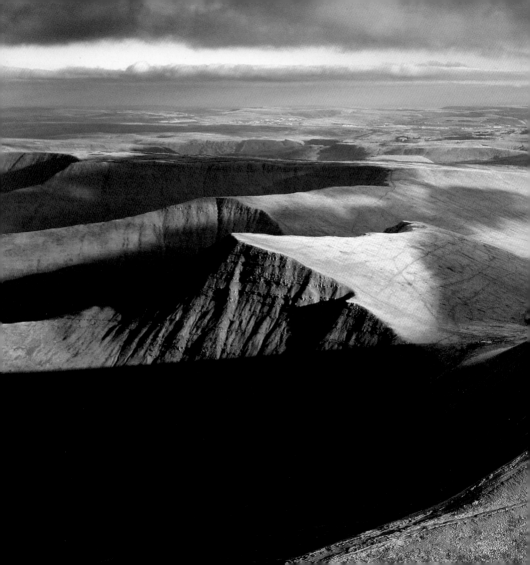

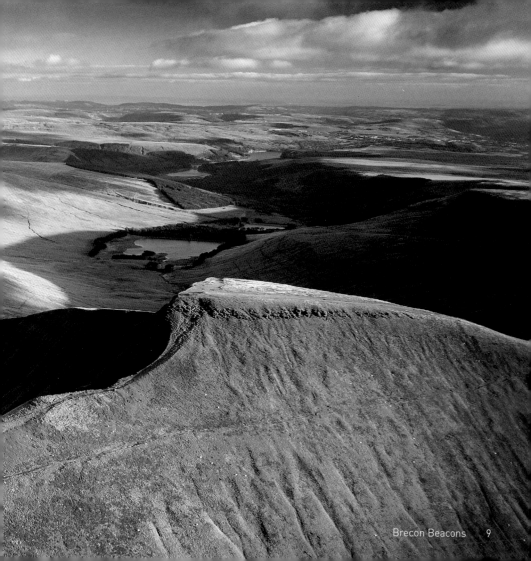

AUTHOR'S CHOICE

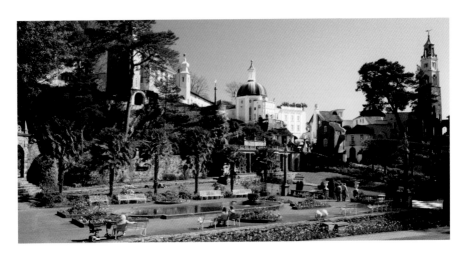

These are twelve of my favourite locations from across Wales. The selection was a difficult process, narrowing down the vast number of Wales' beautiful sites to just a dozen. I have sought to achieve a balance that includes locations from across the whole of Wales, with representation from the rolling uplands and the sweeping lowlands; the world-famous coastlines and the lush, green interior; the urban and the rural; the natural and the man-made.

These places are all personally relevant and significant to me, but each is rich with history and they all have their place in the story of Wales.

PORTMEIRION

Soaring spires, recycled colonnades, a Buddha discarded from a film set. The stylised, brightly coloured, Mediterranean fishing-village houses of Portmeirion have become an iconic image of north Wales.

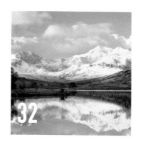

SNOWDONIA AND CAPEL CURIG

Ancient. Strong. Rugged. Proud. Overseeing Gwynedd and, seemingly, the whole of Wales is Yr Wyddfa - Snowdon - the highest mountain in Britain outside Scotland.

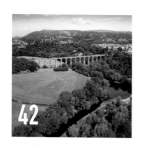

LLANGOLLEN AND THE DEE VALLEY

Stepping boldly across the Dee Valley, just east of Llangollen, is the UNESCO World Heritage Site of the Pontcysyllte Aqueduct.

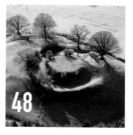

SYCHARTH, CYNLLAITH VALLEY

Within this modest, unassuming and quietly beautiful valley, just a shout from the border with England, lies a deeply significant and important place in the story of Wales.

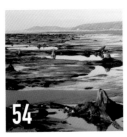

BORTH AND CARDIGAN BAY

Arcing in a broad sweep from Bardsey
Island and the Llŷn Peninsula in the north to
Strumble Head on the Pembrokeshire Coast
is Cardigan Bay.

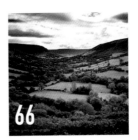

CAPEL-Y-FFIN, THE VALE OF EWYAS

Sometimes known as Llanthony Valley, the
Vale of the Ewyas is the steep sided valley
of the River Honddu in the Black Mountains
on the eastern side of the Brecon Beacons
National Park.

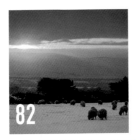

FOEL CWMCERWYN, PRESELI HILLS

This treeless, open, ancient ridge of igneous
rock rises from the plateau of south
Pembrokeshire and the rolling countryside
to the north, rather as a majestic figure
would arise from their chair.

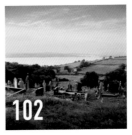

GOWER AND THE LOUGHOR ESTUARY

Gŵyr, or Penrhyn Gŵyr, is the peninsula
that forces itself out into the Bristol Channel
for some 20 miles beyond the urban fringe
of west Swansea.

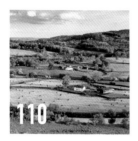

TYWI VALLEY

The Tywi Valley, Dyffryn Tywi , is perhaps the most understated yet most attractive of all the river valleys in Wales.

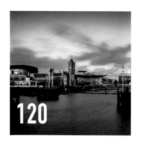

CARDIFF AND CARDIFF BAY

Cardiff has been a city since 1905 and then, fifty years later, became the capital of a resurgent Wales; home of BBC Wales, the National Museum Wales, the National Assembly for Wales and the Welsh Government.

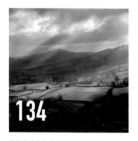

SUGARLOAF MOUNTAIN

The Sugarloaf Mountain dominates the skyline of the eastern Brecon Beacons National Park at nearly 2,000ft, 596m, high.

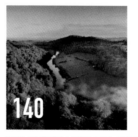

THE WYE VALLEY AND SYMONDS YAT

The River Wye, Afon Gwy, is the fifth longest and one of the cleanest rivers in Britain. It is also one of the most beautiful.

NORTH
WALES

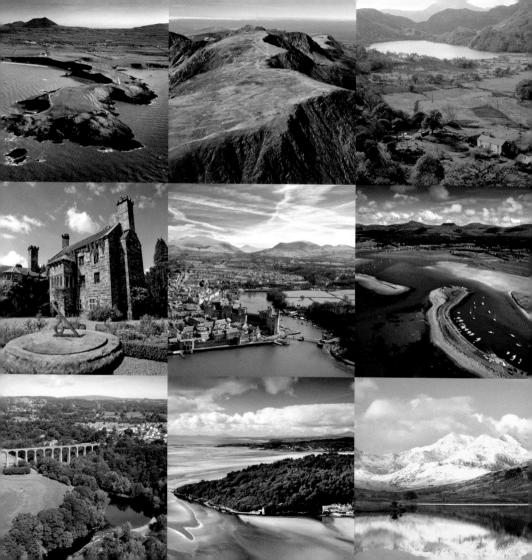

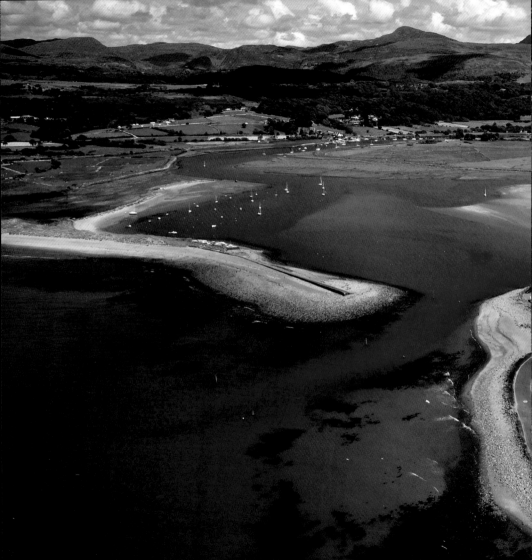

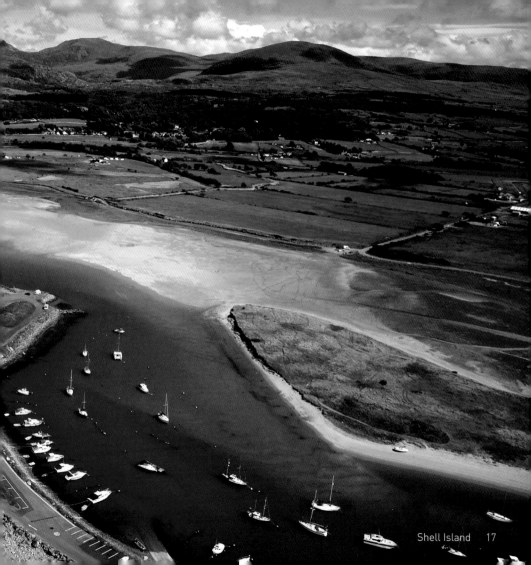

PORTMEIRION

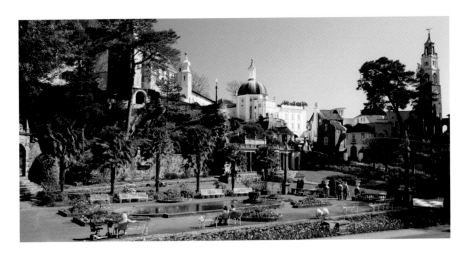

Soaring spires, recycled colonnades, other bits and pieces left over from fallen buildings and a giant Buddha discarded from a film set. The stylised, brightly coloured, Mediterranean fishing-village houses of Portmeirion have become an iconic image of north Wales.

The slightly surreal but utterly captivating Italianate village of Portmeirion is located in Gwynedd, north Wales, just off the A487, south of Porthmadog. It sits amidst tumbling woodlands and subtropical gardens (with a treasure trove of exotic plants) on the Aber Iâ peninsula, overlooking Traeth Bach and the expanse of Cardigan Bay. It was once described by architecture critic Lewis Mumford as 'an artful and playful little modern village (...) that is a deliberately irresponsible reaction to the dull sterilities of (...) modern architecture.'

In the eyes of many Portmeirion appears to be anachronistic within the setting of the natural majesty of the Snowdonia National Park. However for its creator, Sir Clough William-Ellis, there was a comfortable synergy between his exploration of creating the delightful with the conservation of the natural landscape of Snowdonia. Born in Northamptonshire in 1883 he briefly studied architecture in London before entering private practice in London and Merioneth. In 1908 he inherited Plas Brondanw from his father and in 1930 donated mountain land he owned to the National Trust.

Throughout his life he became a tireless, leading advocate and voice for the National Park movement in Britain. He was also a key figure in getting Snowdonia designated as a National Park in October 1951, following recommendations from the National Park Commission on which he proudly served as a member. In his book, *Architect Errant*, he wrote 'I had long been envious of those other countries that had National Parks and most gladly served on the original Government Committee that was appointed to consider the establishment of such in England and Wales.'

However, it was in the village of Portmeirion where his passion, vision and idealism would come togther into a project which would, ultimately, last most of his life. For in 1925 Sir Clough Williams-Ellis set about creating his ideal village, arguably drawing inspiration from the Italian village of Portofino 'as an almost perfect example of the man-made adornment and use of an exquisite site.' He wanted to demonstrate that it was possible to develop a beautiful site without defiling it and, 'indeed given sufficient loving care, that one might even enhance what nature had provided as your background.' He also wanted to stimulate the public's interest in architecture, landscape and design alongside the notion that, in his words, 'good architectural manners can also mean good business.'

Undoubtedly these goals have been fulfilled as today Portmeirion is one of the most photographed and visited attractions in Wales, complete with the quality Castell Deudraeth Hotel and the highly sought after tickets for the No. 6 music and culture fesitval which references the cult status 1960s TV series *The Prisoner*, filmed at Portmeirion.

The result of a very personal project of Sir Clough Williams-Ellis which lasted from 1925-1975, Portmeirion continues to evolve under the management of his family and the stewardship of a charitable trust.

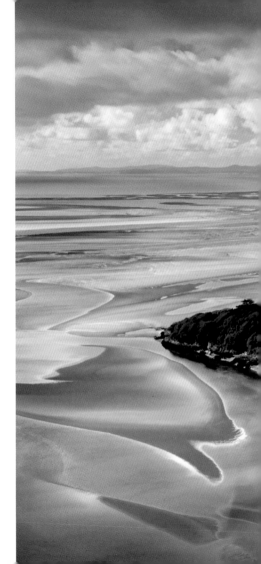

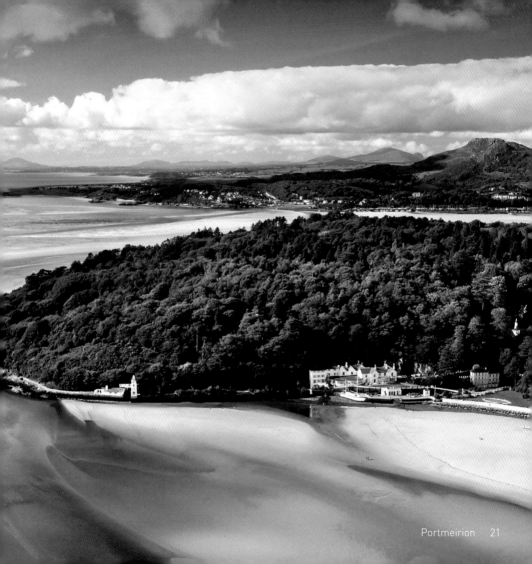

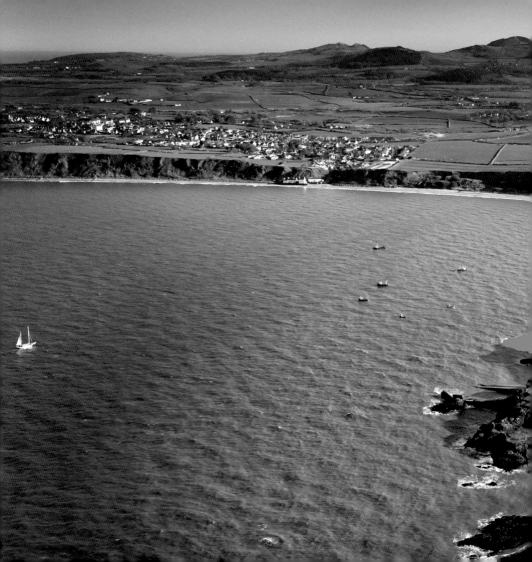

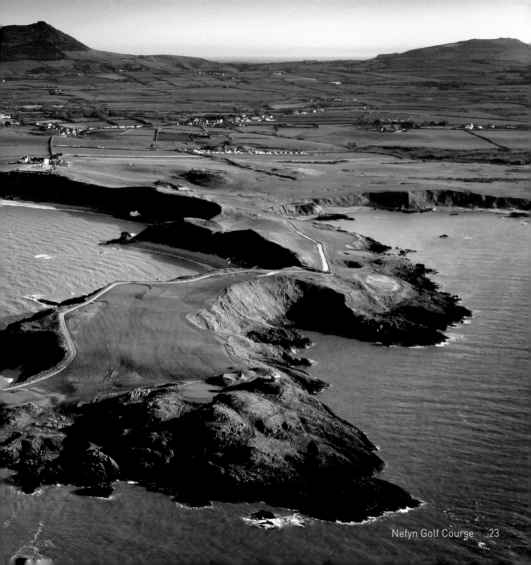

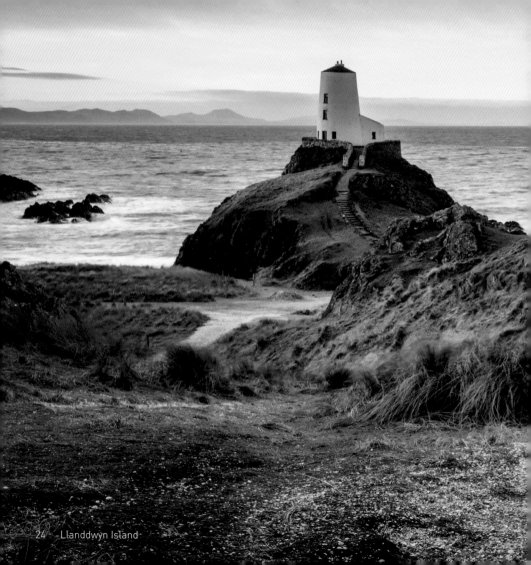

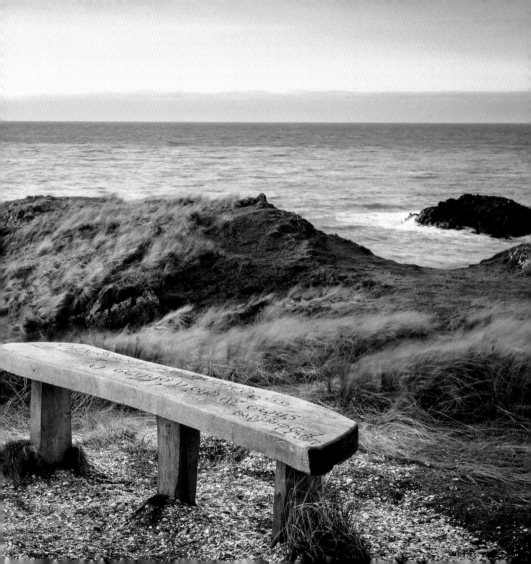

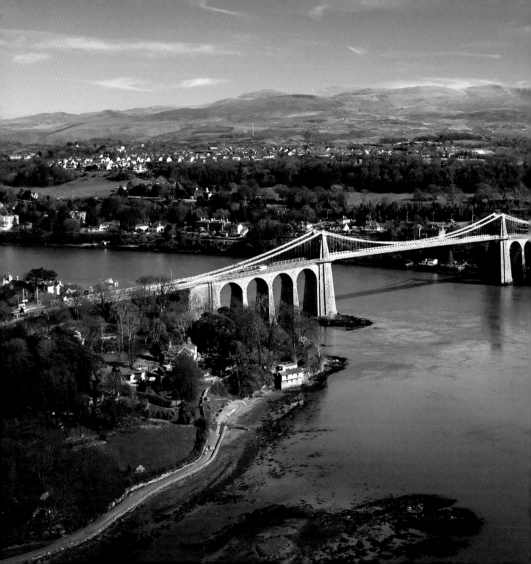

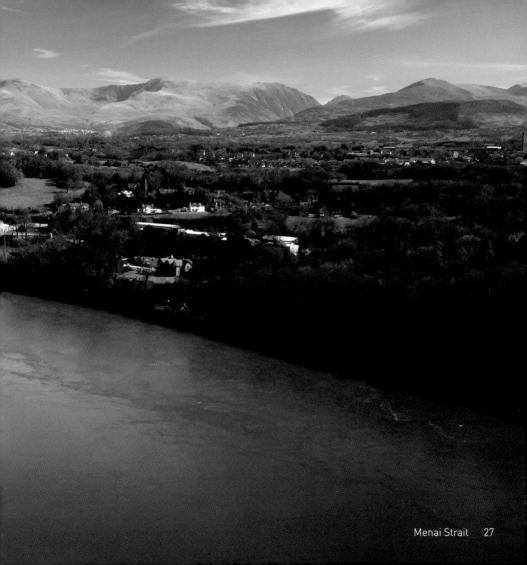

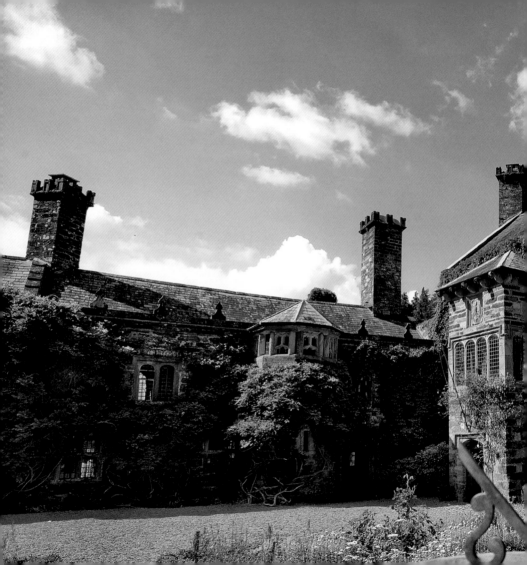

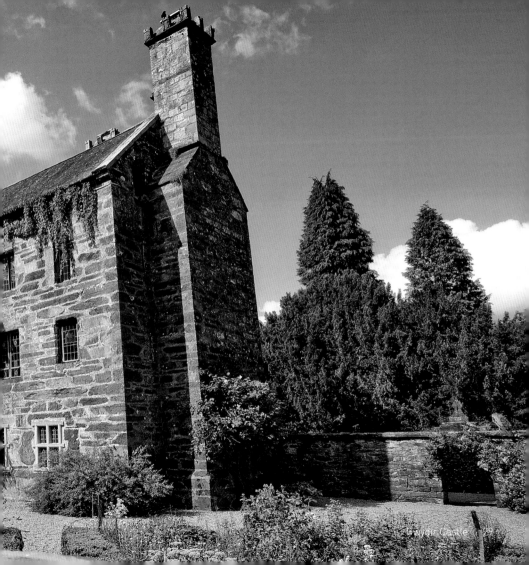

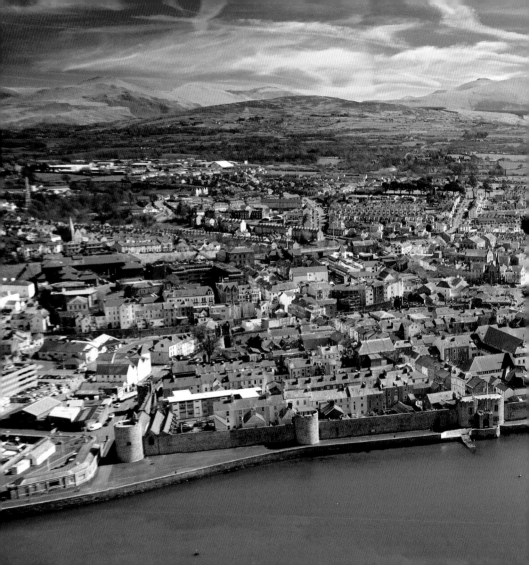

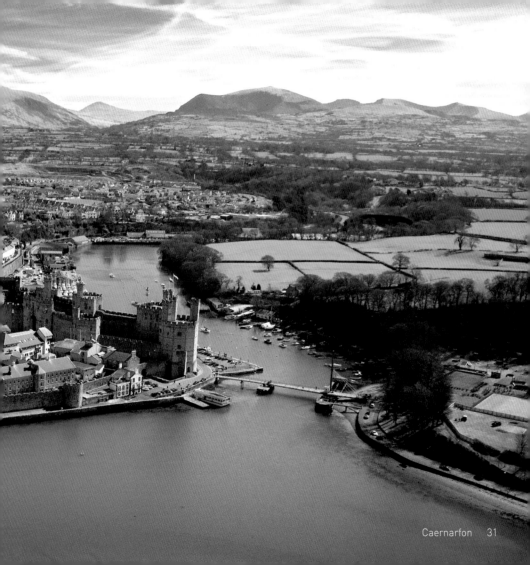

SNOWDONIA AND CAPEL CURIG

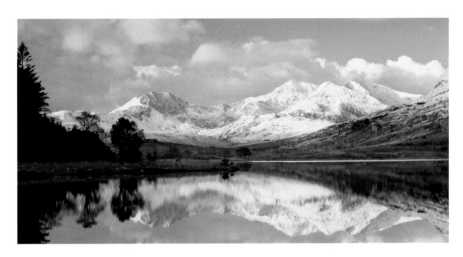

Ancient. Strong. Rugged. Proud. Overseeing Gwynedd and, seemingly, the whole of Wales is Yr Wyddfa – Snowdon. At 3,560ft, 1,085m, this is the highest mountain in Britain outside of the Scottish highlands.

It is alpine topography. Ordovician volcanic rock sculpted by glaciers creating the distinctive peak; the sharp arêtes of Yr Lliwedd and Crib Goch; the rock faces and scree slopes of Glaslyn and Llyn Llydaw with their scooped out cup-shaped cwms. It is alpine, but it's also about as Welsh as you can get.

Snowdon is the sentinel of north Wales. From its summit, on a clear day, it boasts the most extensive views; across Wales, over to Ireland, to England and then, beyond, to Scotland. A prospect which takes in an incredible 24 counties, 27 lakes and 17 islands.

Today's Snowdon is a busy place. Often described as 'Britain's busiest mountain' with over 250,000 visitors to its summit each year, it is one of the locations of the UK's Three Peaks Challenge and at the heart of the route of the Snowdonia Marathon – twice voted as Britain's best marathon. The first recorded ascent of the mountain was in 1639 by botanist Thomas Johnson. In the 1950s Snowdon was used by Sir Edmund Hillary and his team in practice for their successful attempt on scaling Mount Everest in 1953.

Today it is possible to reach the summit using the 1896 Snowdon Mountain Railway – a 4.7-mile narrow gauge rack and pinion railway that runs from the village of Llanberis at the base of the mountain. Or, for a more strenuous climb, there are a number of well established, engineered and managed footpaths, the main ones being the Watkin Path from Nant Gwynant; the Pyg and Miners' tracks from Pen-y-Pass; the Snowdon Ranger and Llanberis Paths and the Rhyd Ddu Path. Crib Goch is one of the finest ridge walks in Britain; however, be warned, this climb is discouraged because of the severe difficulty of the route.

At the summit of Snowdon is Hafod Eryri, a £8.6m award-winning visitor centre designed by Ray Hole Architects. It opened in 2009, replacing the previous railway station terminus and café which was built in 1934 by Sir Clough Williams-Ellis, the architect and vision behind Portmeirion village.

The area of Snowdonia, Yr Eryri, is of course, far more diverse than simply its highest peak. It embraces both mountains and coastline, stretching from Aberdyfi in the south to Colwyn Bay in the north, with a border that takes in the whole of the Llyn Peninsula. It was designated a National Park in 1951, the first area in Wales to become one. Wales now has three National Parks. Snowdonia National Park, an area

of 823 square miles, is home to 26,000 people, of whom two thirds speak Welsh. Over three-quarters of the land is in private ownership, with areas managed by Natural Resources Wales for commercial timber production. The Park is increasingly used for recreation and amenity purposes with some 1,479 miles, 2,380km, of public footpaths alone. The National Trust owns a further 8% of the land.

Within this wonderfully diverse landscape there are many opportunities for outdoor adventure activities. Indeed, Snowdonia has now become the outdoor adventure centre of Britain, upstaging and aping previous claims by other destinations in England and Scotland. The range of activity to set the adrenalin running is extraordinary: from white water kayaking, to the world's longest ziplines, to trampolines in abandoned underground slate quarry chambers, to world class mountain biking and of course, there is mountain climbing and the world renowned National Mountaineering Centre at Plas y Brenin, Capel Curig. So go on, what are you waiting for?

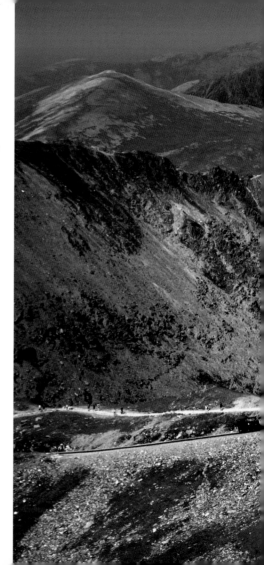

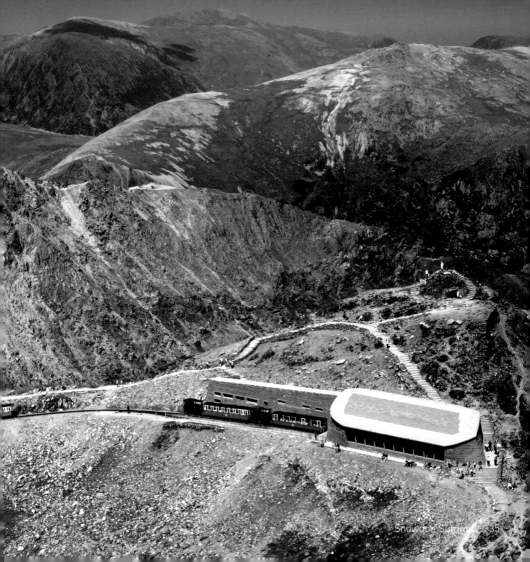

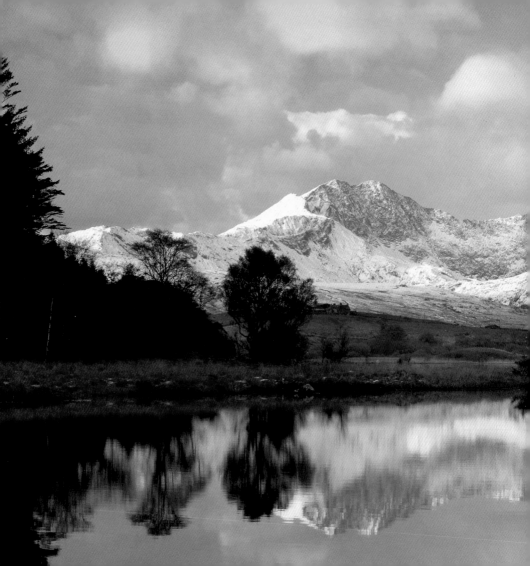

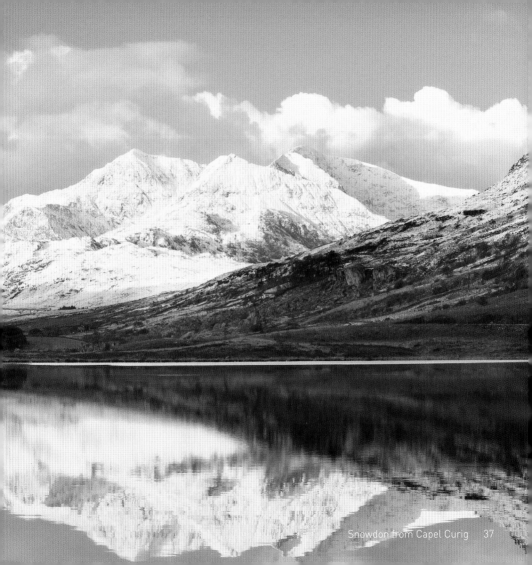

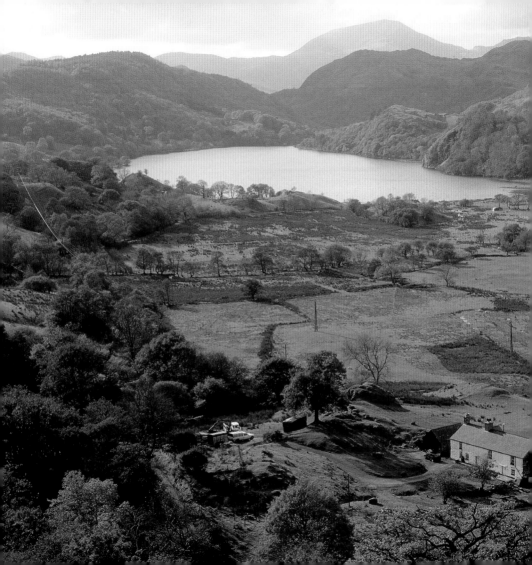

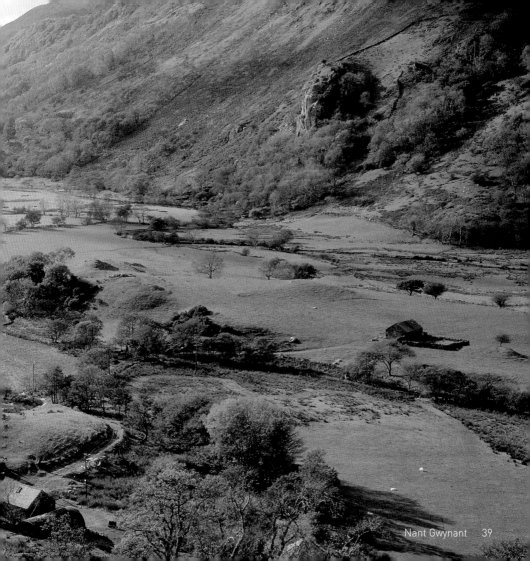

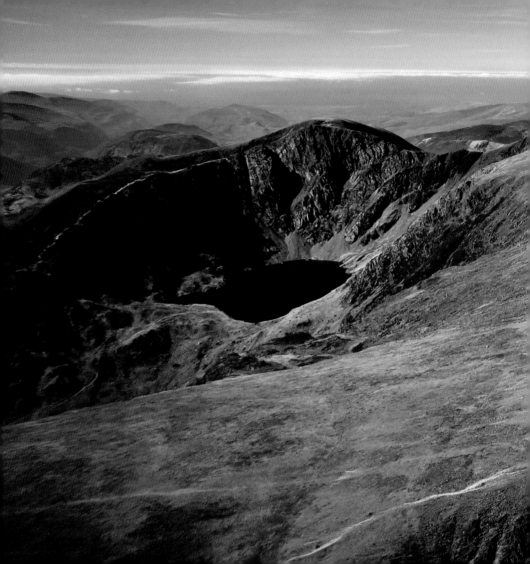

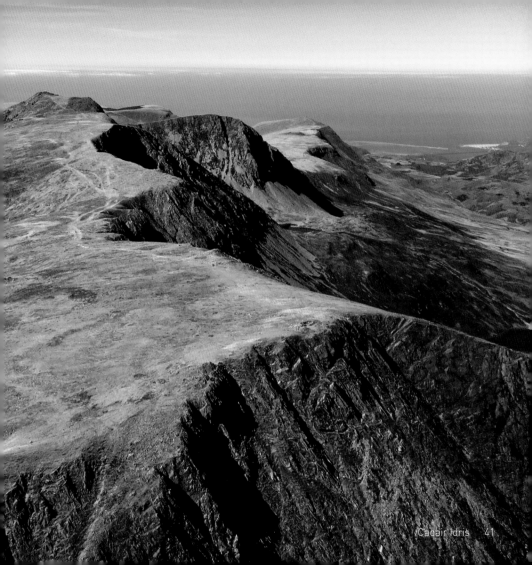

LLANGOLLEN AND THE DEE VALLEY

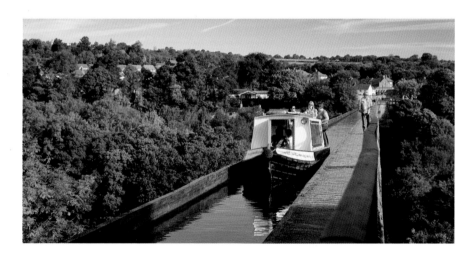

Stepping boldly across the Dee Valley, just east of Llangollen, is the UNESCO World Heritage Site of the Pontcysyllte Aqueduct.

Inscribed on the UNESCO list of World Heritage Sites in 2009, this remarkable navigable 'stream in the sky' was completed in 1805, ten years after the first stone was laid. Designed by Thomas Telford and constructed under the watchful eye of canal engineer, William Jessop, for many years this was the highest canal structure in the world at 126ft, 38m, high. The nineteen arches, each with a 45ft span, supported by 18 slender pillars held together with a mortar mix of lime, water and ox blood, connect the villages of Pontcysyllte and Trevor.

Originally part of the Ellesmere Canal, what is now known simply as the Llangollen Canal was once part of the Shropshire Union Canal network. As well as being used for the transportation of commercial goods, the canal also supplied water, drawn from the Horseshoe Falls just north of Llangollen, to a number of Cheshire towns. Today the canal is used for recreational purposes, with the aqueduct being the highlight for suspended boat rides as well as offering visitors the chance to walk its 1000ft span.

The aqueduct is glimpsed through woodland at a number of viewpoints on the A5 travelling towards Llangollen from the east and the A483 between Wrexham and Oswestry. Moel-y-Gamlin and the top of the Horseshoe Pass, the A452, originally a turnpike road built in 1811 to link the Dee Valley with towns and villages to the north, offer the best views of Llangollen. This former coaching stop on the route between London and the seaport of Holyhead is now a centre for tourism anchored by its annual International Music Eisteddfod and associated Fringe Festival.

Local people established the International Eisteddfod in 1947 as a contribution to healing the wounds and repairing international relationships in post-war Europe. A key element of the festival remains the coming together of musicians and folk dancers from around the world and the delivery of a message of peace by the festival's young participants.

The River Dee bisects the town. Fast flowing at this point, it has developed as a centre for white-water kayaking and canoeing, complimenting the gentler water-based activities associated with the canal and the walking and cycling opportunities in the surrounding countryside.

The light coloured carboniferous limestone escarpment is a dramatic backdrop that appears to be hanging above the north of the town. Here you find the Panorama Walk, the intriguingly named 'World's End', and The Eglwyseg Rocks view points. A mile or so north-east of the town is an open hilltop crowned with the striking ruins of Castell Dinas Bran – a Welsh walled castle and stronghold of the Princes of Powys. In 1201, under patronage of one of the Princes, Madog ap Gruffydd Maelor, the Cistercians founded Valle Crucis Abbey at nearby Llantysilio, where the monks, according to contemporary poets anyway, lived liked lords.

MID
WALES

SYCHARTH AND THE CYNLLAITH VALLEY

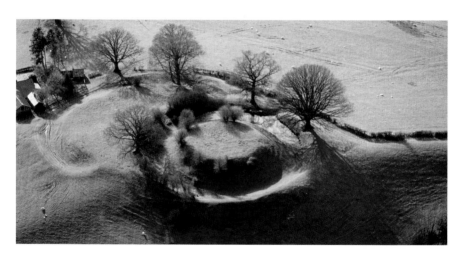

Within this modest, unassuming and quietly beautiful valley, just a shout from the border with England, lies a deeply significant and important place, one which is embedded in the story of Wales as a nation and ingrained in the collective memory of its people.

This is land of the Welsh Marches – a borderland for two thousand years between two distinct peoples and cultures. It is often referred to as an upland countryside, but this is not wild, open moorland. Instead it is very much a landscape of rolling hills fractured by wooded escarpments that frame the broad valley floor of the River Cynllaith and its tributaries, Nant Moelfre and Afon Ogau.

There is, however, very much an upland 'feel' to this scene, with the peaks of Hen Graig, Foel Wylfa and Gyrn Moelfre lifting the eye. Gyrn Moelfre at 1,716ft, featured as a location in the 1995 film starring Hugh Grant, *An Englishman Who Went up a Hill and Came Down a Mountain*, telling the story of two English cartographers who, in 1917, went to measure the height of a mountain and found it only qualified to be a hill – until, that is, the proud local villagers got involved!

At the mid-point of the east-west oriented valley, less than a stone's throw from the border with Shropshire, is the small village of Llansilin, the most northerly community in the county of Powys. Just south of here, when following the river upstream in a westerly direction for a few miles along the sinuous B4580, the valley opens out revealing what remains of an important medieval township. Looking south across the base of the valley at this point there sits a low knoll topped by a majestic oak tree. This is Sycharth, Owain Glyndŵr's court, thus making it one of the most important and symbolic historical sites in Wales.

Standing at Sycharth there is an overpowering sense of tranquillity and peace infused with the knowledge that you are somewhere very special. Sycharth's splendour and Glyndŵr's fine hospitality is vividly praised in a poem written in the 1390s by the contemporary bard, Iolo Goch, who referred to it as 'a good place, a place of generosity (...) a fine wooden house atop a green hill (...) within a ring of bright water.' However, of more significance, around six hundred years ago this was the focal point of a nation. From this former Norman stronghold, Glyndŵr emerged as a leader for Welsh independence in a rebellion against the English. Sycharth was itself burnt to the ground in 1403 by Prince Henry, later Henry V. Yet for many Welsh people the significance of that bid for self-governance remains, and Glyndŵr himself remains the Last Prince of Wales.

This landscape is full of surprises, from the sublime to the extraordinary. For the sublime travel north of Llansilin to the village of Llanrhaedr-ym-Mochnant where, in the sixteenth century, Vicar William Morgan made the first translation of the Bible into Welsh and thereby arguably secured the future of the language itself. For the extraordinary, in 1996 TNS, the local football team of Llansantffraidd-ym-Mechain, took on Ruch Chorzów of Poland and their five Polish international players. having won the Welsh FA Cup and thereby qualified for the UEFA European Cup Winners Cup. They drew at home before losing away but, proving this was no fluke, in subsequent seasons the likes of Manchester City, Liverpool and Anderlecht all had cause to look up the name.

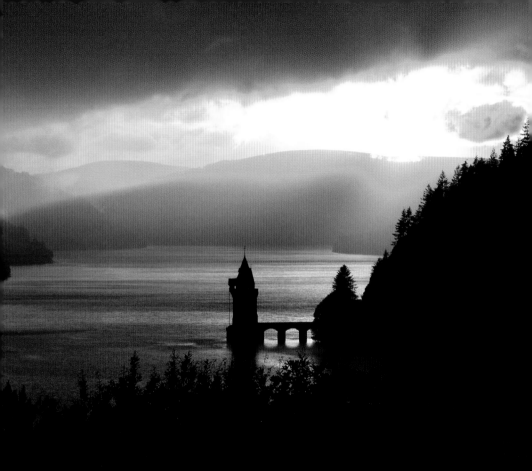

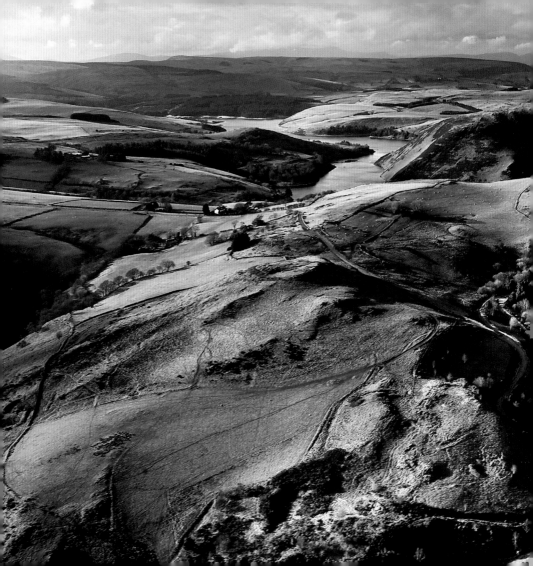

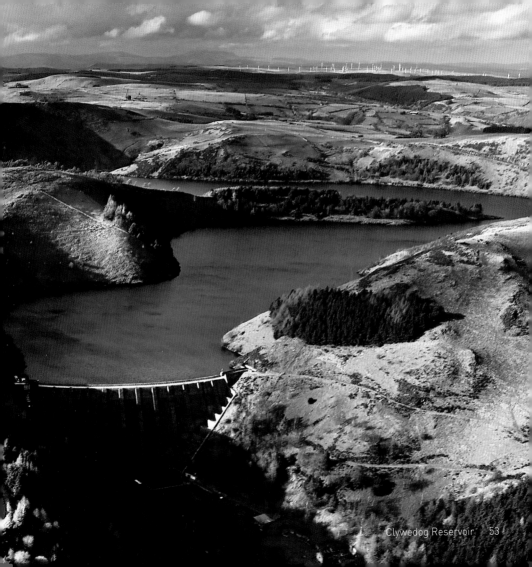

BORTH AND CARDIGAN BAY

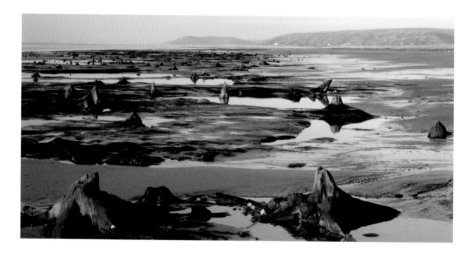

Arcing in a broad sweep from Bardsey Island and the Llŷn Peninsula in the north to Strumble Head on the Pembrokeshire Coast is Cardigan Bay. This is a magnificent part of the 700-mile coastline of Wales – a coastline that now, with the All Wales Coast Path having been completed, can be walked in its entirety.

For those in a car or on a motorbike, the coastal roads A487 and A493 provide one of the most dramatic coast routes in the world, with a landscape of constantly changing drama and beauty comparable with road trips on the coast of California and South Africa.

It is the sheer variety of landscape that delights. In the north are the open, sandy beaches of Harlech, Tywyn and Barmouth and the major dune system at Ynyslas, all set against the backdrop of Snowdonia and mid-Wales and divided by the spectacular estuaries of the Dyfi, Mawddach and Glaslyn rivers. Travelling south, the coastline becomes more rugged with rocky headlands and steep cliffs hiding shingle banks and storm beaches. South of Aberystwyth, the flat, raised beaches either side of the colour-washed harbour of the Georgian New Town of Aberaeron are fertile pasture lands.

Pitted along this coastline is a myriad of small towns and villages. Many began as centres of shipbuilding or as harbours: New Quay, Aberaeron, and Porthmadog. At the turn of the 19th century, the port of Cardigan, at the southern end of the bay, was more important than those of Cardiff or Swansea. Over 300 ships were registered in Cardigan: seven times as many as Cardiff and three

times that of Swansea. In 1831 Llan-non, whose church dedicated to St Non, mother of St David, sits on a raised beach almost touching the sea, the majority of male adults in a population of less than 1,900 were ship builders. Later the village would produce many great sea captains.

For many other towns on Cardigan Bay it was tourism that sustained their existence: Aberystwyth, Barmouth, Tywyn, Aberdyfi and Borth all developed as resort towns in the 1950s and 1960s attracting tourists from the north and central regions of England. Today, most of the coastal communities have a strong tourism economy, developing their appeal based on outdoor activities, maritime heritage and, increasingly, wildlife exploration. Cardigan Bay is now a Special Conservation Area and a prime UK location to see grey seals, harbour porpoise and bottlenose dolphins.

Cantre'r Gwaelod, or the Welsh Atlantis, is a legendary lost kingdom off the coast of Cardigan Bay. It is evidenced at Borth and Ynsylas by the remains of fallen trees and stumps of ancient oaks, willows and hazel. These tangible links to ancestral landscapes, visible at low tide, were observed by Gerald Cambriensis in 1188 and by Samuel Pepys in 1665 on their tours of Wales. These are landscapes swamped by rising sea levels as a result of melting glaciers over many centuries. The submerged forest at Ynyslas died 5,500 years ago; the one at Borth just 2,000 years ago. Climate change, more frequent storms and rising sea levels remain a concern for the communities of Cardigan Bay and are a major topic of academic research in Aberystwyth University.

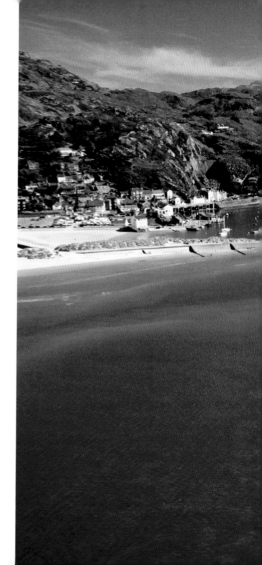

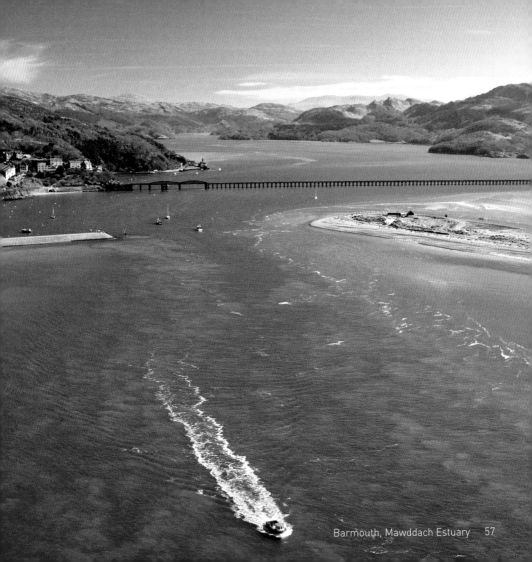

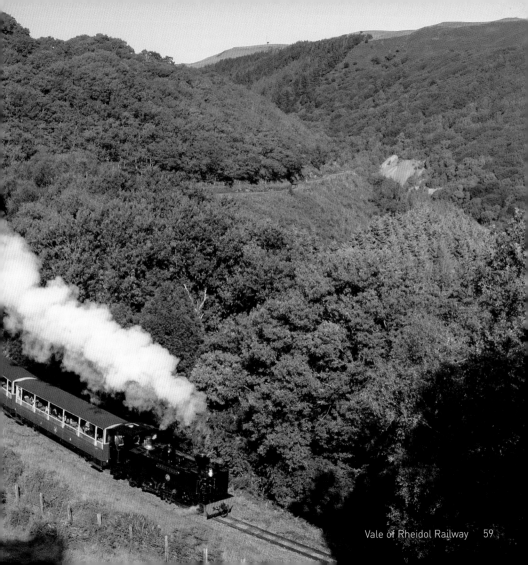

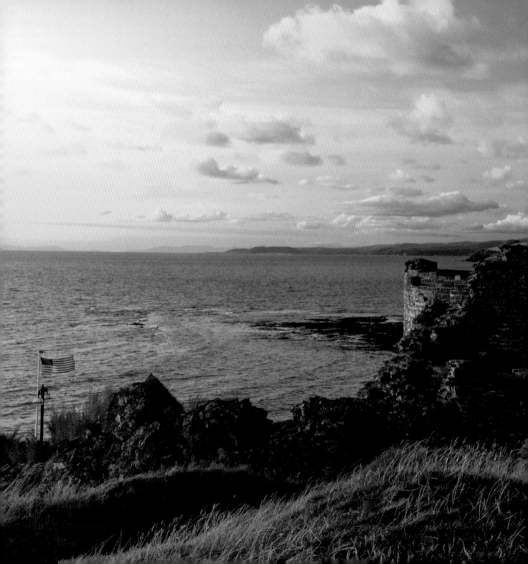

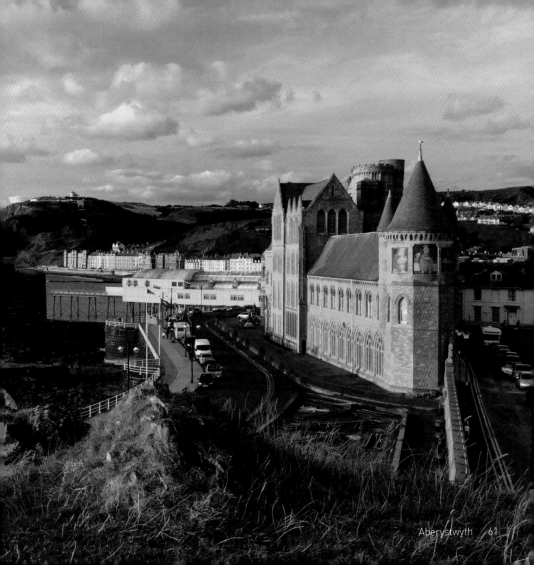

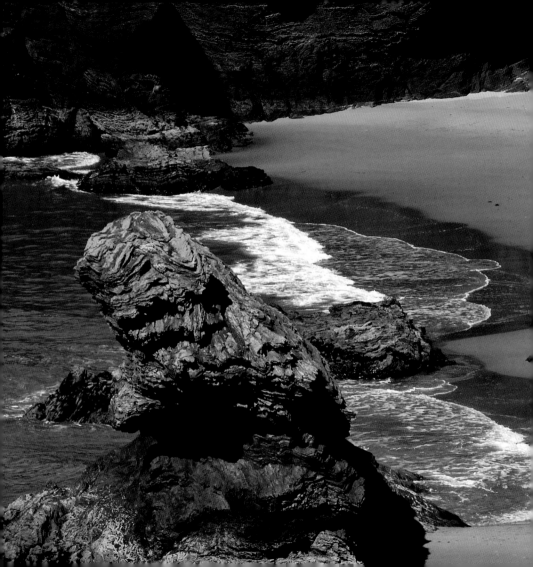

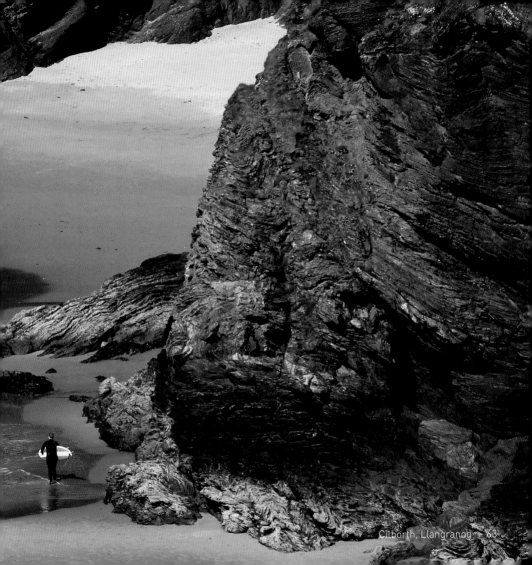

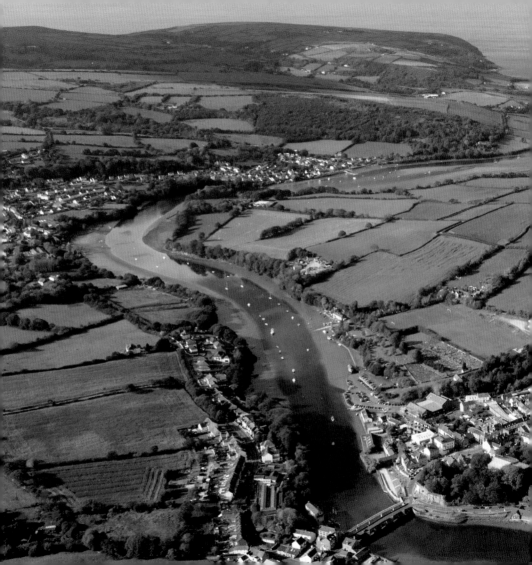

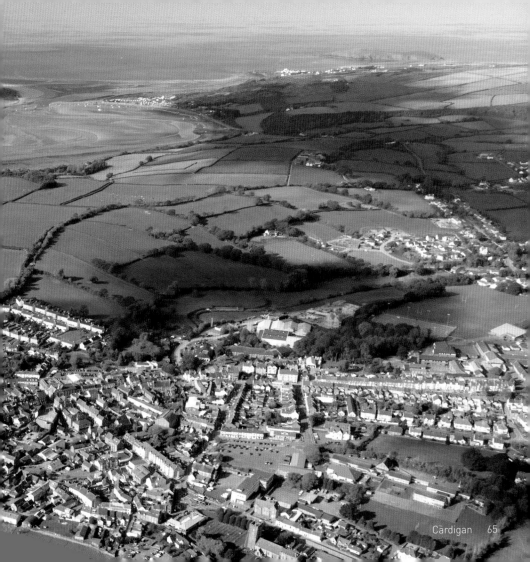

Cardigan 65

CAPEL-Y-FFIN AND THE VALE OF EWYAS

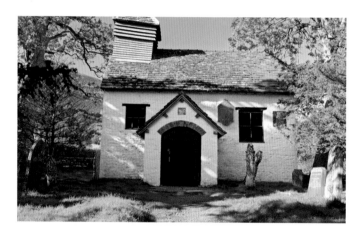

Sometimes known as Llanthony Valley, the Vale of the Ewyas is the steep sided valley of the River Honddu in the Black Mountains on the eastern side of the Brecon Beacons National Park – an area of countryside featured in Bruce Chatwin's *On the Black Hill* and Raymond Williams' *People of the Black Mountains*.

The River Honddu is pursued through the valley bottom by a single-track road linking Hay-on-Wye with the A465 at Llanvihangel Crucorney. Running along the Hatterall Ridge to the north, overlooking the Olchon Valley, is part of Offa's Dyke, Clawdd Offa – a large linear earthwork that roughly follows the current border between England and Wales. Today designated a National Long Distance Footpath, the structure is named after Offa, the 8th century king of Mercia who, it is believed, ordered its construction.

This secluded and relatively difficult to negotiate U-shaped valley has the Gospel Pass, at 1,801ft, 549m, the highest road pass in Wales, at its head where the River Honddu rises. Farms in this part of the valley, such as the Grange, reflect the extent of the land once owned by the former Augustinian monastery at Llanthony Priory. In the 11th century the Norman conqueror Water de Lacy became a hermit at Llanthony, founding the priory in 1103. The Priory fell into disrepair after the dissolution of the monasteries by Henry VII in the sixteenth century and it next came to prominence in 1794 when its ruins were the subject of a painting by J.M.W. Turner. It is now part of the Cadw: Welsh Historic Monuments portfolio of heritage sites and a starting point for a range of fine local walks

– especially to Y Twmpa and Lord Hereford's Knob.

At the base of the Gospel Pass is one of the smallest and most secluded places of worship in Wales. Capel-y-Ffin, meaning 'boundary chapel', is a hamlet that marks where the road and river enter Monmouthshire from Breconshire. The tiny St Mary's Church of the hamlet was built in 1792. It is just 26ft by 13ft, 8m by 4m, in size and is embraced by what appears to be its own woodland, causing 19th century curate and diarist Francis Kilvert to liken the chapel to an owl whilst bemoaning the presence of 'loathsome British tourists.'

Tourists have been travelling here for centuries seeking peace and spirituality. Travel writer Ben Mallalieu described it as 'timeless [...] a place where the outside world ceases to matter.' In 1869, long after the dissolution of the priory, Joseph Lyne, known as the self-styled Father Ignatius, tried to re-establish monastic life in the valley with the re-building of a monastery in the village. The structure is now fenced off and unsafe to enter.

The disused monastery was sold in 1924 to a religious community led by artist and designer Eric Gill, seeking to establish another unconventional form of religious community. Their search for the idyllic lasted a short while, hampered by the crumbling house, but it was here that Gill created the typefaces known as Gill Sans and Perpetua, used in printing all over the world.

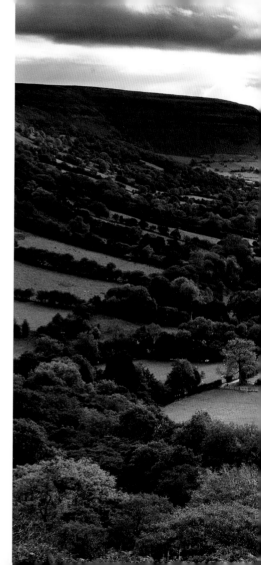

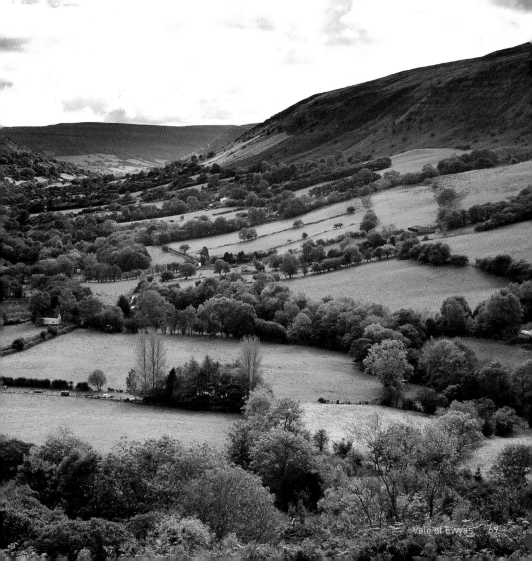

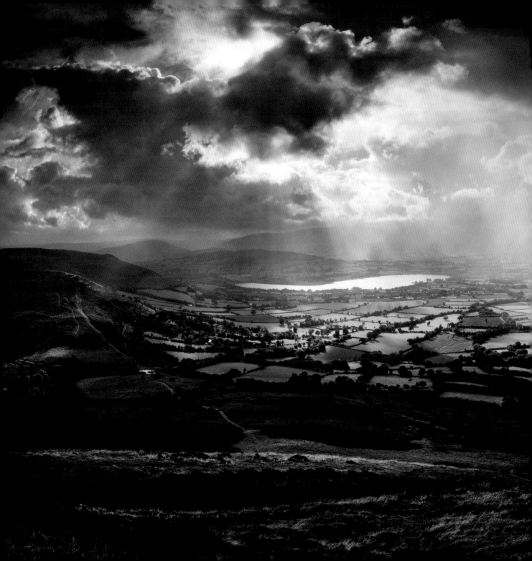

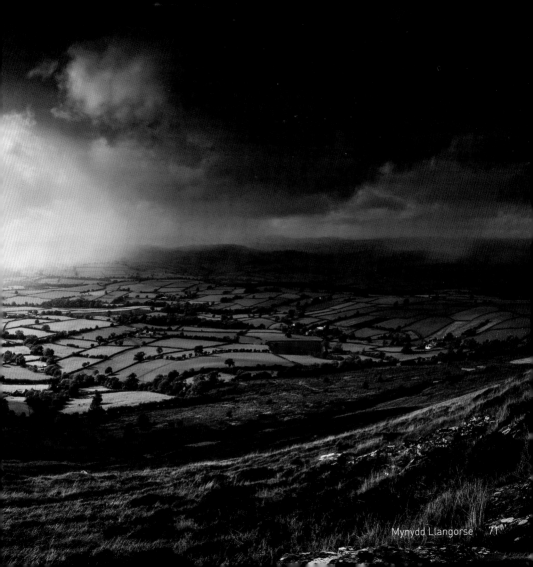

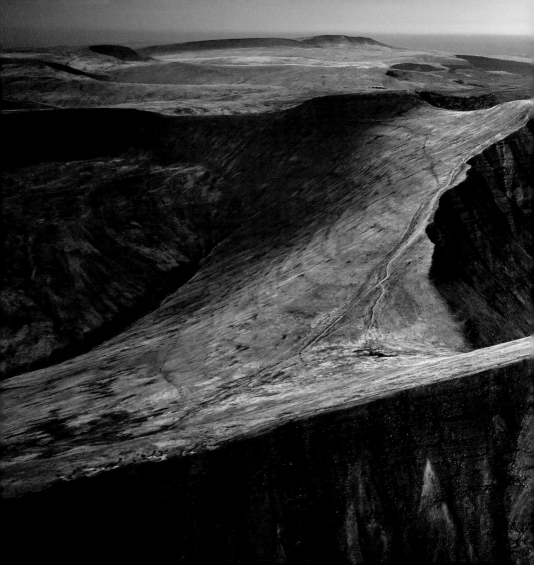

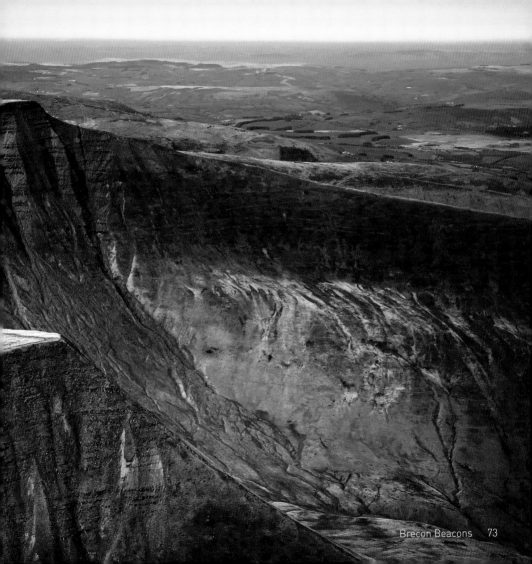

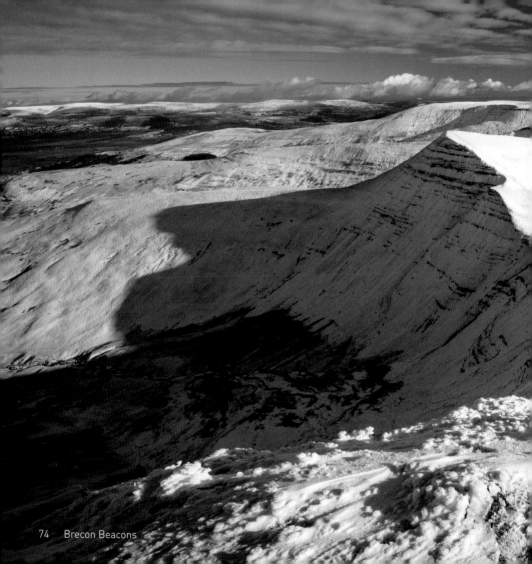

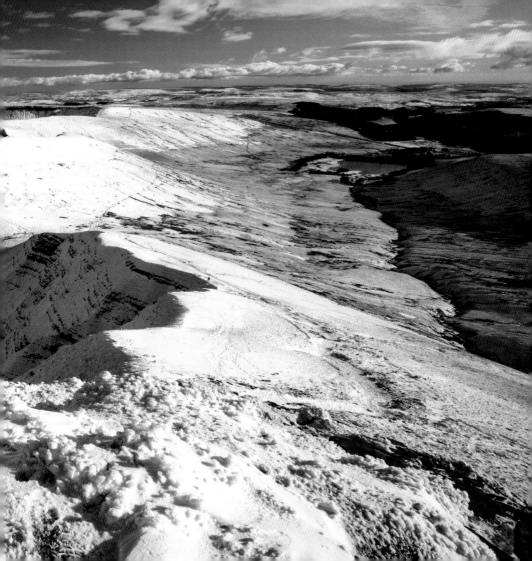

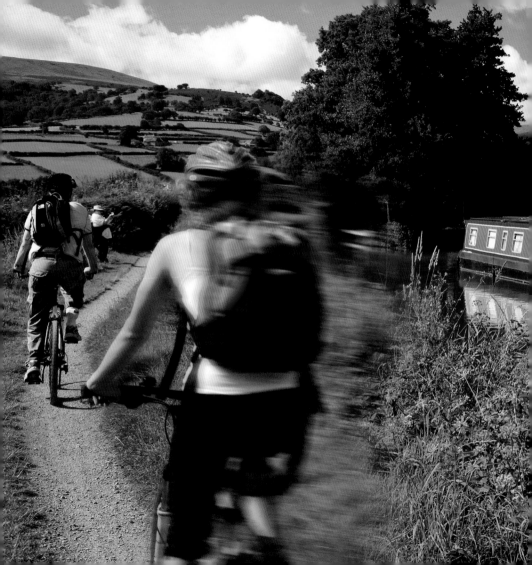

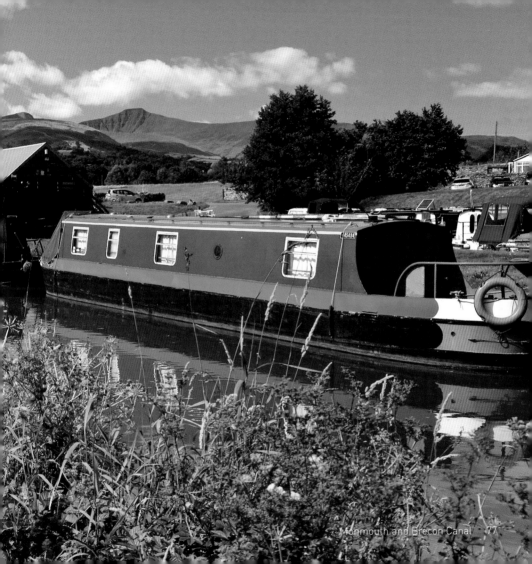

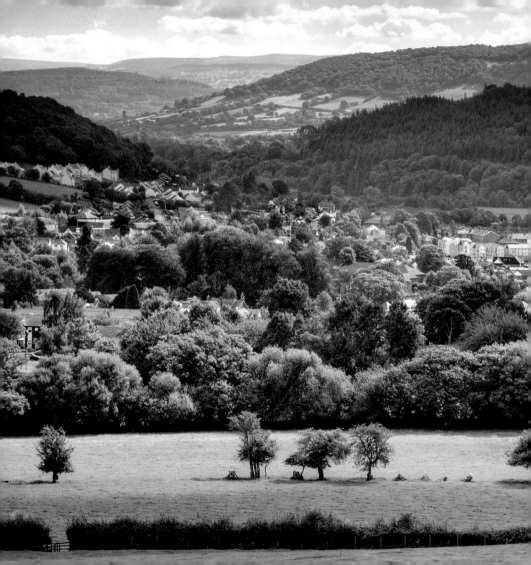

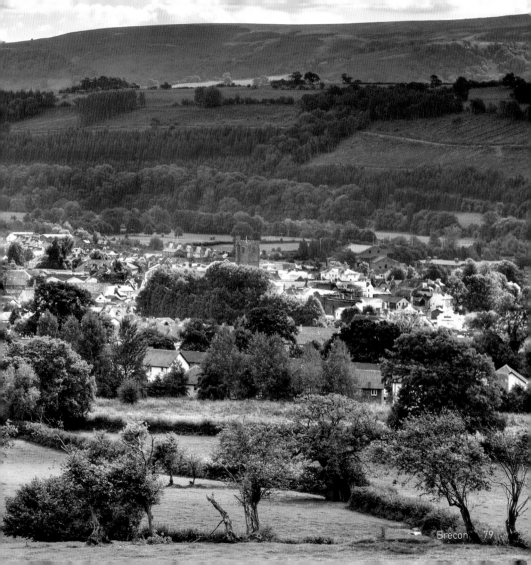

WEST
WALES

FOEL CWMCERWYN, PRESELI HILLS

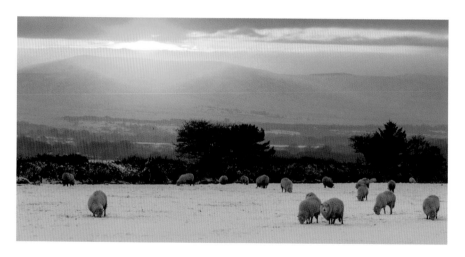

This treeless, open, ancient ridge of igneous rock rises from the plateau of south Pembrokeshire and the rolling countryside to the north, rather as a majestic figure would arise from their chair.

The Preseli Hills arch across the landscape for 12 miles, 20km, from Cardigan Bay in the west to Crymych in the east. Ancient and timeless, the Mynyddoedd y Preselau are enigmatic – at the same time both brooding and beguiling. Mostly made up of common land it is land which is used for grazing sheep that overwinter on the lowlands in the south of the county.

This is a landscape known in Welsh as "gwlad hud a lledrith" land of myth and enchantment. The Preselis never fail to deliver on this promise. Foel Cwmcerwyn, at 1,759ft, 536m, the highest point in the range, presides over 14 other peaks as well as the sacred sites, places of myth and legend, ancient hill forts, standing stones and the Welsh communities of Eglwyswrw, Brynberian, Blaenffôs, Mynachlog-ddu and Maenclochog.

From this summit one experiences the most expansive and maybe even the best view in the whole of Wales; across Cardigan Bay to Snowdonia and Llyn in the north, to the Brecon Beacons in the east, and to Gower and Milford Haven in the south and west. Uninterrupted wonderment, bar for those days when the low clouds with mystical qualities envelop the mountains.

This is a very special place, full of surprises. At its base, just north of Maenclochog, is Rosebush – a very English punctuation mark in a very Welsh environment. The slate quarries at Rosebush flourished in the 19th century and roofed the Houses of Parliament. The Maenclochog Railway (1876) terminated in the village, allowing it to develop as a tourist resort 'for those seeking nature and repose', as well as a source of slate. The former resort hotel, *Tafarn Sinc*, built in 1876, is today a thriving village pub. The Bluestones used in the building of Stonehenge were sourced from Carn Meini. The mountains, once desired by the UK Government for use as a permanent military training ground, were the inspiration for the poetry of Waldo Williams, a pacifist who was headmaster at Mynachlog-ddu school. His writing focuses upon the feelings of belonging, of the harmonious living that is witnessed in the communities in the Preseli Mountains, perhaps best expressed in his poem '*Cofio*' (*Remembering*, 1936).

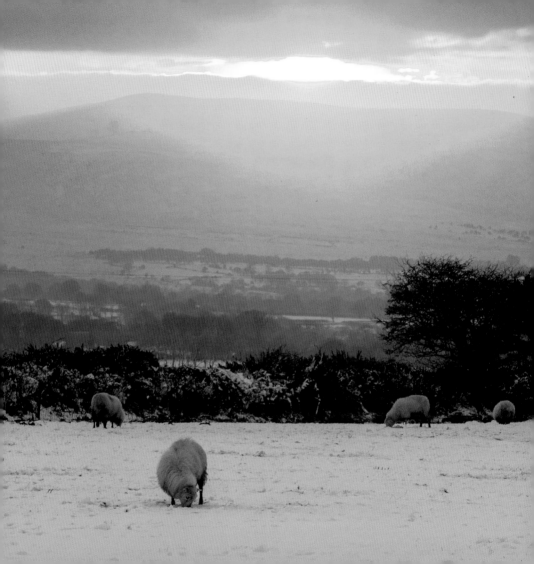

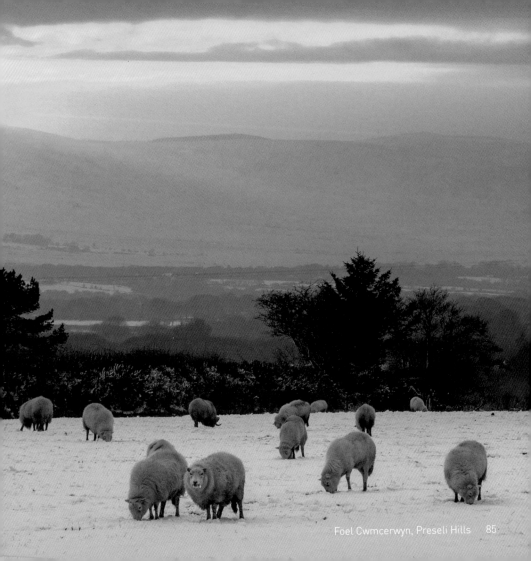

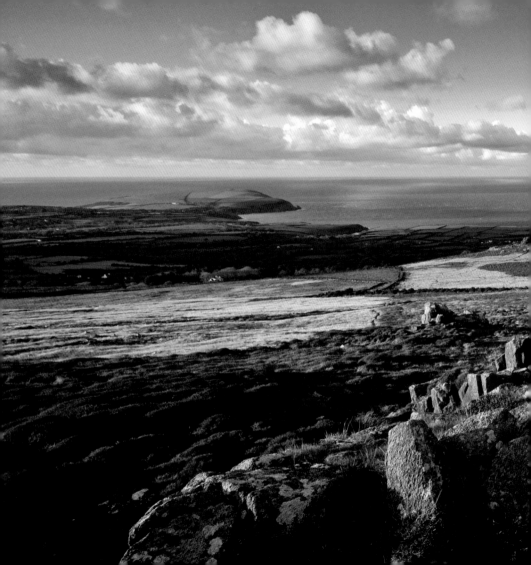

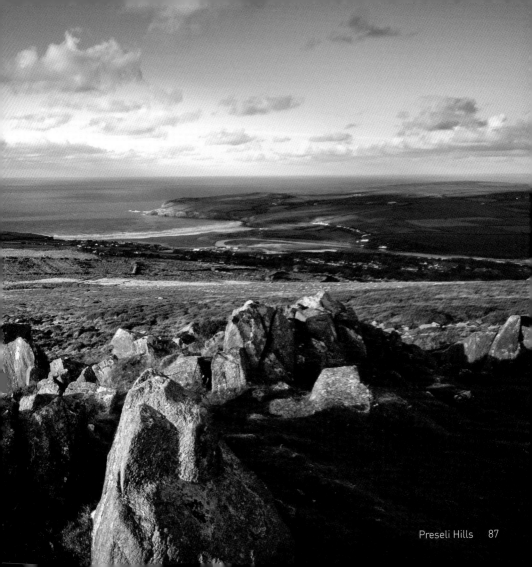

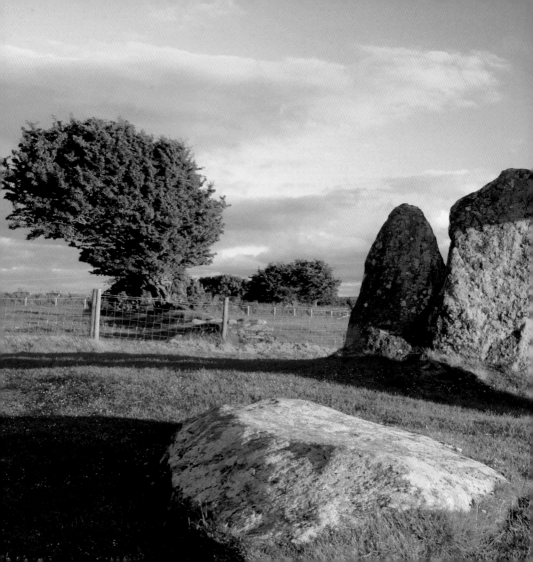

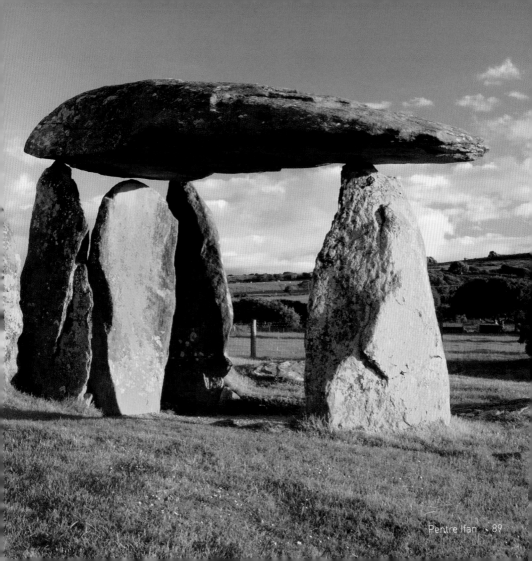

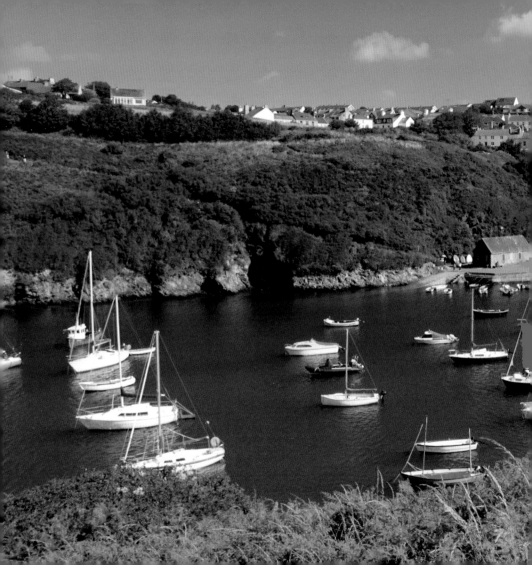

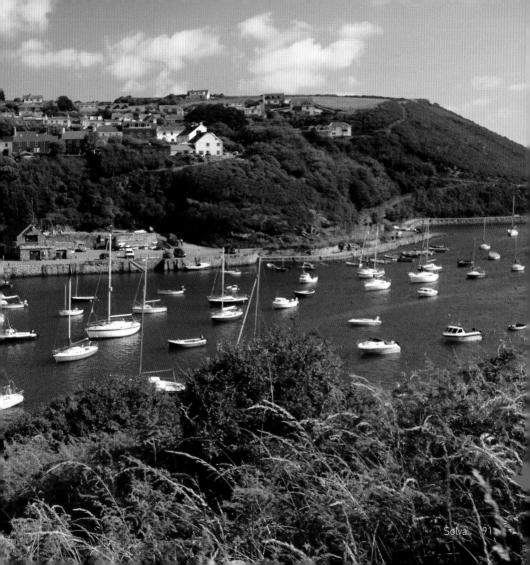

Solva 91

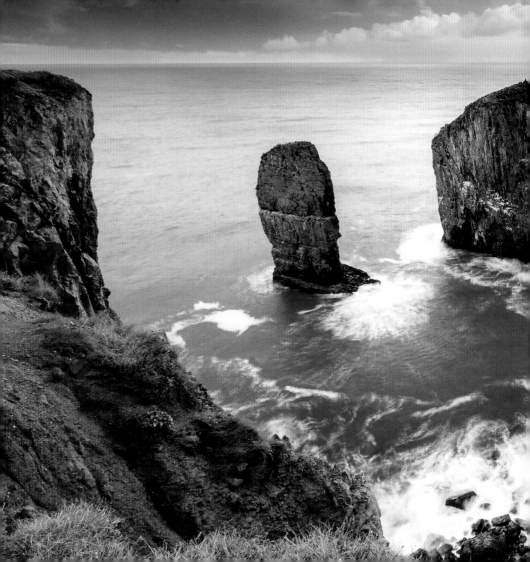

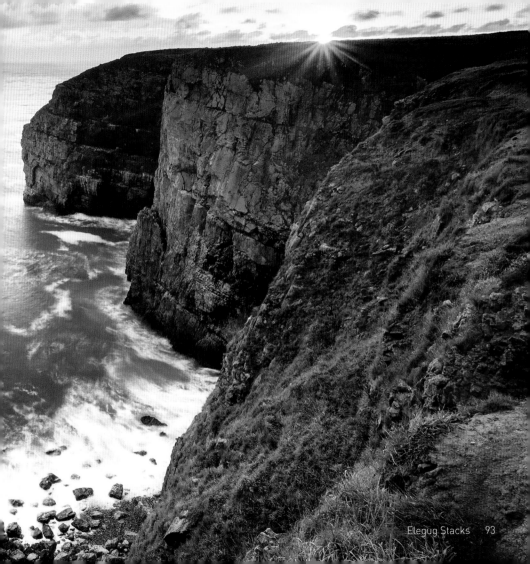

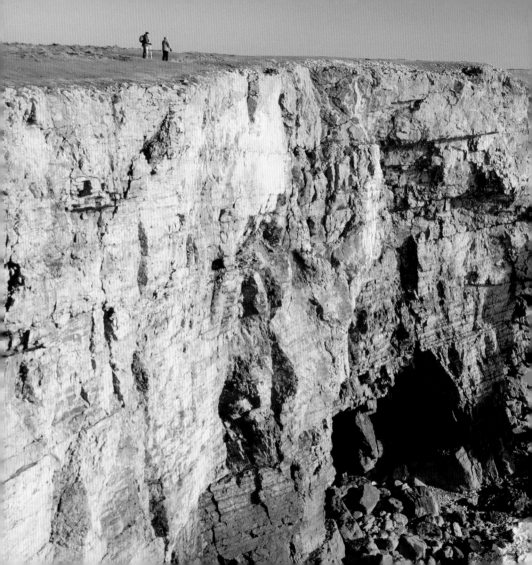

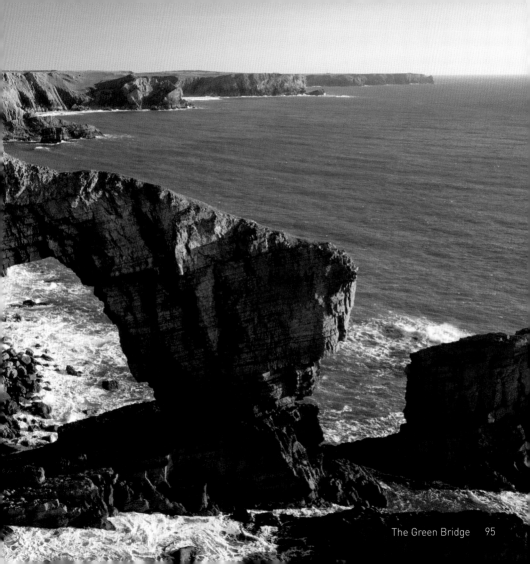

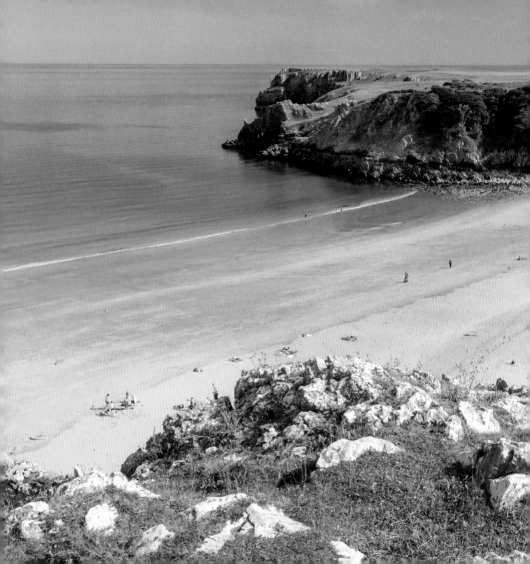

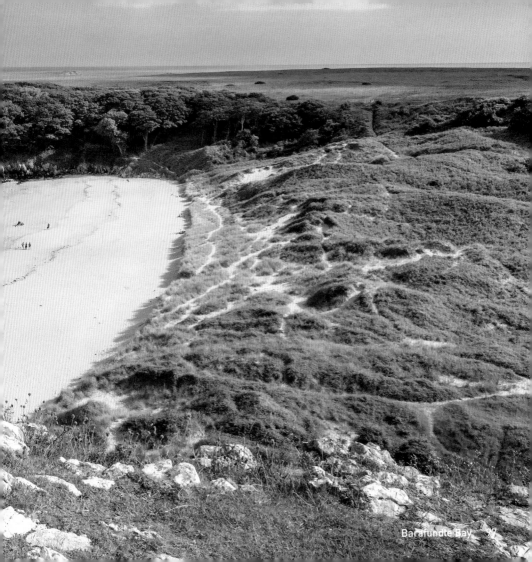

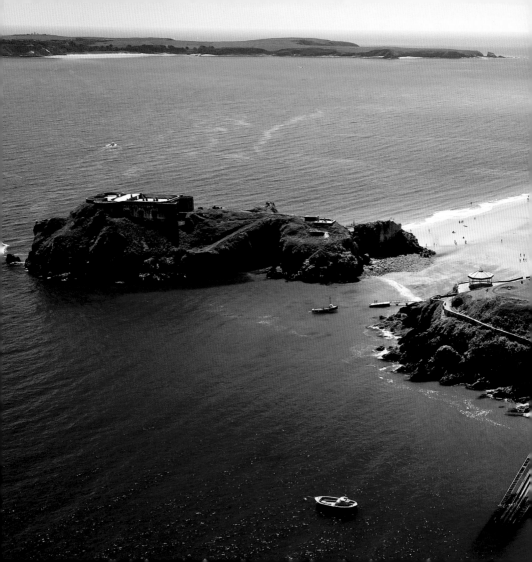

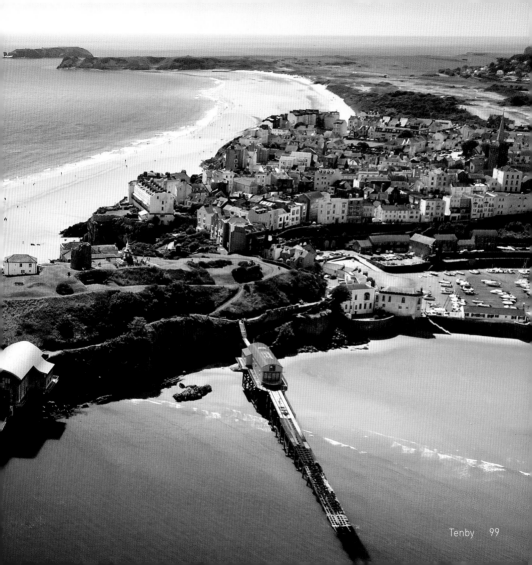

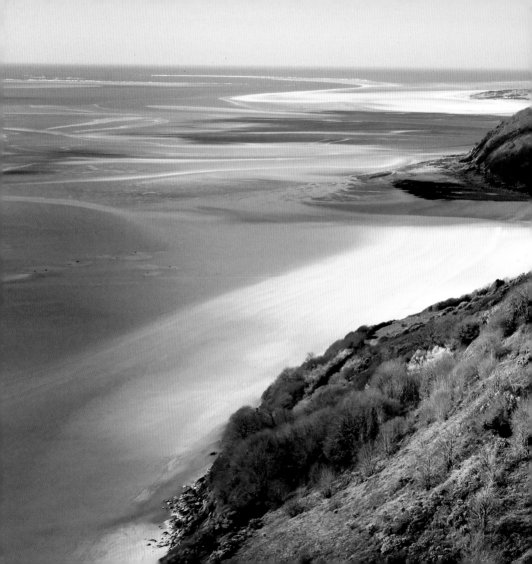

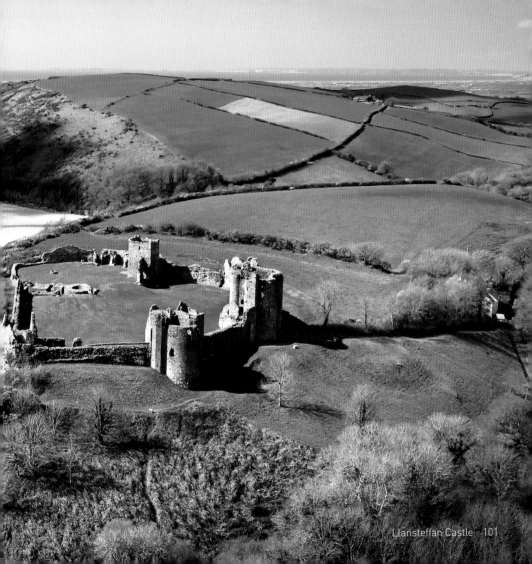

GOWER AND THE LOUGHOR ESTUARY

Gŵyr, or Penrhyn Gŵyr, is the peninsula that forces itself out into the Bristol Channel for some 20 miles beyond the urban fringe of west Swansea, framed by Swansea Bay to the south and the broad sweep of the Loughor Estuary to the north.

The whole of the Gower Peninsula, some 70sq miles, is designated as an Area of Outstanding Natural Beauty with a number of small, attractive villages along its shores. Running through the heart of the peninsula is Cefn Bryn, a five-mile long Old Red Sandstone ridge, 617ft, 188m, above sea level at its highest point. This spine runs through the centre of farmland and common land that forms the interior of the peninsula and is known by locals as 'the backbone of Gower.'

The southern and western coastlines of Gower are known for their small bays and beaches – Langland, Caswell, Pwll Du, Bracelet Bay and the unparalled scenery of Three Cliffs Bay, where Pennard Pill flows into the sea, flanked by three jagged sea cliffs. Then there are the large, wide-open, unspoiled sandy beaches of Oxwich, Port Eynon and Rhossili at the tip of the peninsula. Rhossili is a grand, four-mile sweep of sand where the ocean meets sand dunes and the mass of Rhossili Down, the highest point on Gower. To the north is the village of Llangennith and to the south is the tiny, tidal island known as Worm's Head.

Gower is fundamentally an agricultural landscape famous for its early potatoes, its pasture-lands and its salt marsh lamb,

grazed on the tidal wetlands of the north coast between the villages of Landimore and Penclawdd – the centre for cockling on tidal mud banks. Tourism is also a major contributor to the local economy. Gower has always been a popular family holiday destination, especially appealing for its family seaside activities. It has now become popular with walkers and cyclists, whilst for those interested in water-based activities there is scope for all interests. The thermal currents that rise over Rhossili and Harding's Down make these particularly key locations for hang-gliding.

Gower also boasts an abundance of archaeological sites. Just north of the summit of Cefn Bryn is a Neolithic burial chamber known as King Arthur's Stone. Legend has it that King Arthur threw a stone from Llanelli on the opposite, northern shore of the River Loughor and it landed on this spot. Unlikely as this tale may be, this is the site of one of the most dramatic 360-degree vistas in the whole of south Wales.

To the east lies Dylan Thomas' 'Ugly, lovely town' of Swansea; to the south, across the Bristol Channel, is the coastline of north Somerset and Devon; to the west is Tenby and south Pembrokeshire; to the north west

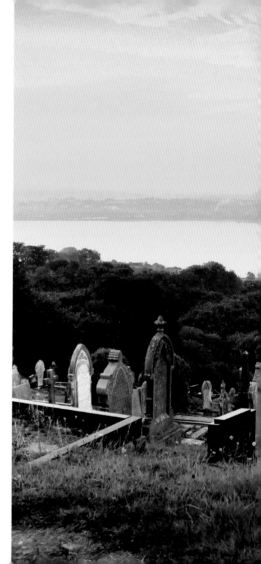

is the summit of Foel Cwncerwyn in the Preseli Mountains whilst northwards is the vast estuary of the River Loughor, which rises some 20 miles north near Castell Carreg Cennen in the Brecon Beacons.

Its source is poetically known as Llygad Llwchwr, The Eye of the Loughor, and, by the time it reaches Loughor, it is a river of great power and dimension. On its eastern bank, across acres of salt marsh are the remains of a Norman Castle, sitting like a small exclamation mark on a headland projecting into the river alongside the new road and railway bridges. Salt Marsh turf was cut here for the first pitch at Wembley Stadium. Built in 1106, Loughor Castle controlled this fording point on the river, a site of strategic importance recognised by the Romans who had previously constructed a regimental fort at what they called Leucarum.

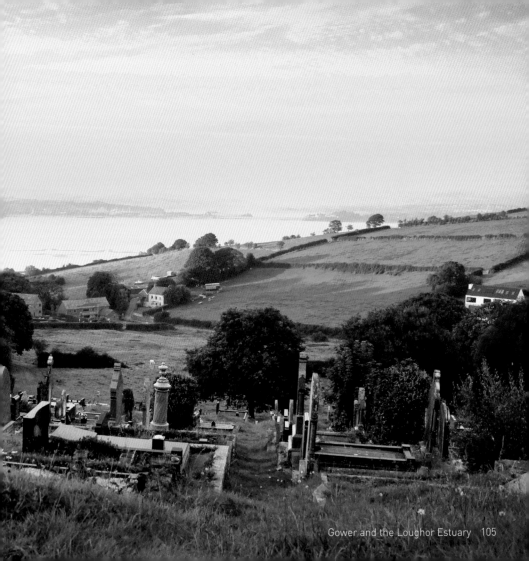

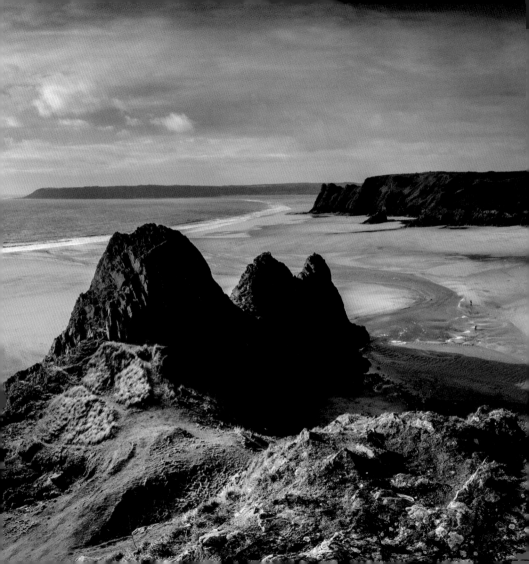

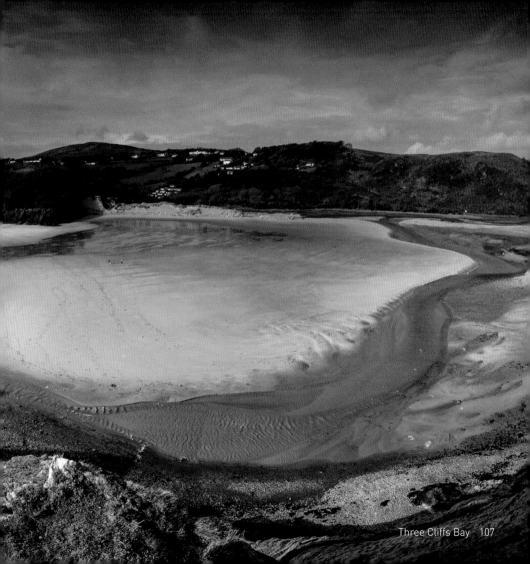

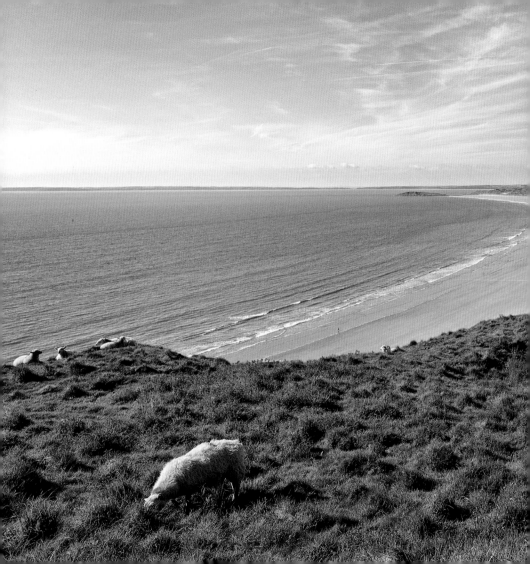

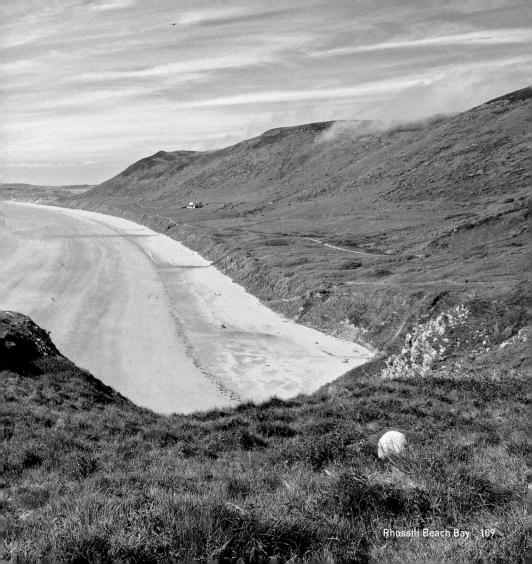

TYWI VALLEY

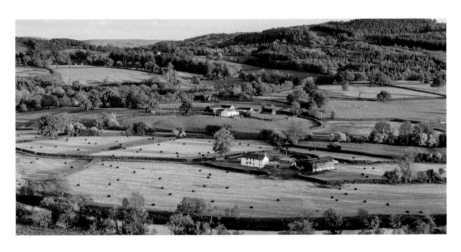

The Tywi Valley, Dyffryn Tywi, is perhaps the most understated yet most attractive of all the river valleys in Wales.

The Tywi Valley is attractive for its physical beauty, its diversity, and for the sheer volume, value and significance of its cultural footprint. A designated 'Special Landscape Area', it is also home to the fabled Physicians of Myddfai as well as Twm Siôn Cati, the Welsh Robin Hood.

Yet as important as these features are, the Tywi Valley is also to be lauded for those less tangible experiences it offers in seemingly inexhaustible supply. The peaceful, graceful meander of its river, a Red Kite soaring above an ancient woodland, or even the view above the mist-filled valley on an autumn morning as you drop down a steep, narrow country lane from the surrounding sunlit hills. All of this and more is to be found in this often forgotten corner of Wales.

The Tywi River rises high up in the rugged, open moorland of the Cambrian Mountains, north west of the former drover's town of Llandovery. This is one of the two longest rivers to flow entirely in Wales, the other is the Teifi. It is some 75 miles, 121km, from its source to the sea in an estuary the Tywi shares with the River Taf at Llansteffan.

The river was dammed in 1972 by the creation of the Llyn Brianne reservoir, some 6 miles, 10km, south of its source. The reservoir controls the flow of the river and allows abstraction further downstream in order to supply urbanised south-east Wales with drinking water. Unlike the appropriation of land in the 1960s for building reservoirs to provide water for English cities, such as at Treweryn, there was little sustained objection to Llyn Brianne being created.

The river flowing in a north-east to south-west direction acts like a ribbon connecting a series of attractive market towns and historic river ports: Llandovery, Llandeilo, Carmarthen – Merlin's town - and Llansteffan. Perched on limestone crags throughout the valley are a series of major castles that are of immense importance in the hearts and minds of the Welsh. Dinefwr and its association with Lord Rhys and the Princes of Deheubarth (the Kingdom of south west Wales), the iconic Carreg Cennen, the 12th century Norman stronghold of Llansteffan and Dryslwyn, a native Welsh castle built by the Princes of Deheubarth in the 12th century.

Dryslwyn was one of the few castles to be occupied by the Welsh until 1291 before it was eventually captured by Edward I, only to be regained for a brief time in 1403 by Owain Glyndŵr. The ruins of Drsylwyn are less dramatic in scale than the others in

the valley but they sit more comfortably in the landscape as a result. In this stretch of the Tywi Valley, between Llandeilo and Carmarthen, a wide level flood plain with ancient hedgerows and meadows lies between the wooded slopes and historic parklands of Dinefwr and Gelli Aur. This is the home of the Wales National Botanic Garden and the wonderfully restored gardens at Aberglasney.

John Dyer, a 17th century painter and poet much praised by Wordsworth, lived at Aberglasney during his childhood. He is best known for one of his earliest poems, 'Grongar Hill', which describes the wildlife and landscape at the heart of the Tywi Valley. It captures the beauty of the Tywi and made it an icon for the picturesque movement, attracting artists such as J.M.W. Turner and other writers throughout the 19th century who were drawn by this cultural landmark. Later, Dylan Thomas writing in his Boat House at Laugharne, close to where the Tywi empties into the sea, made mention of Grongar Hill when the Rev. Eli Jenkins in 'Under Milk Wood' refers to 'Golden Grove, near Grongar'.

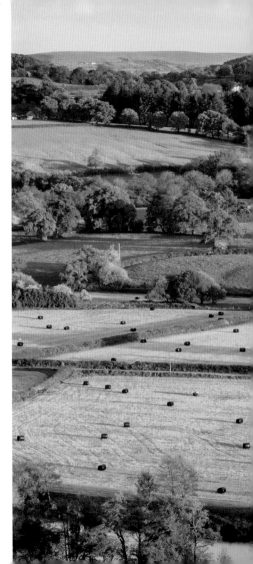

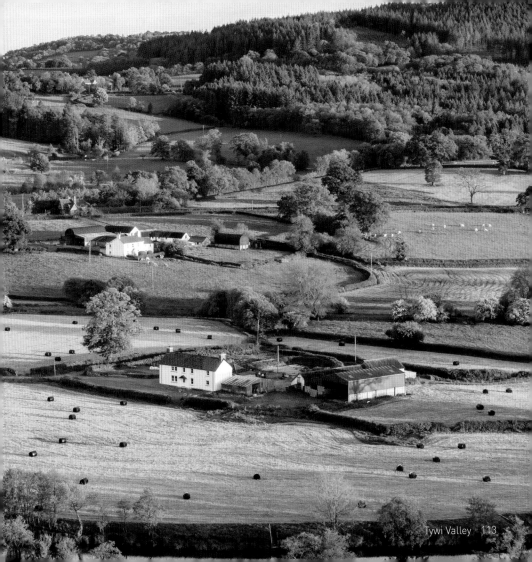

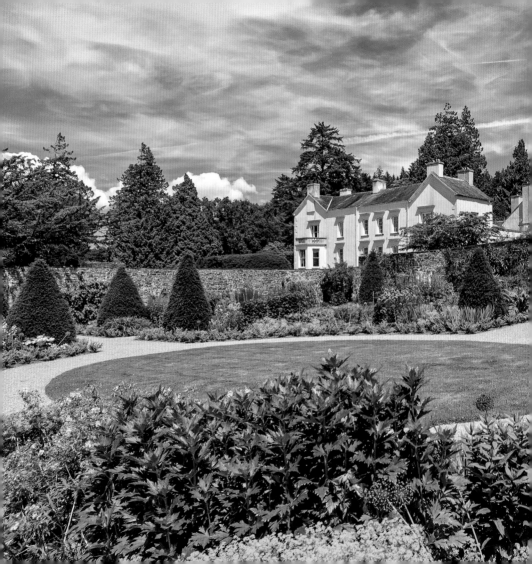

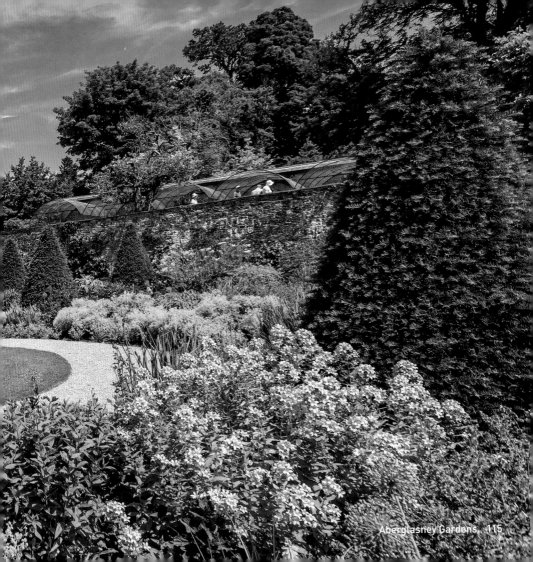

SOUTH
WALES

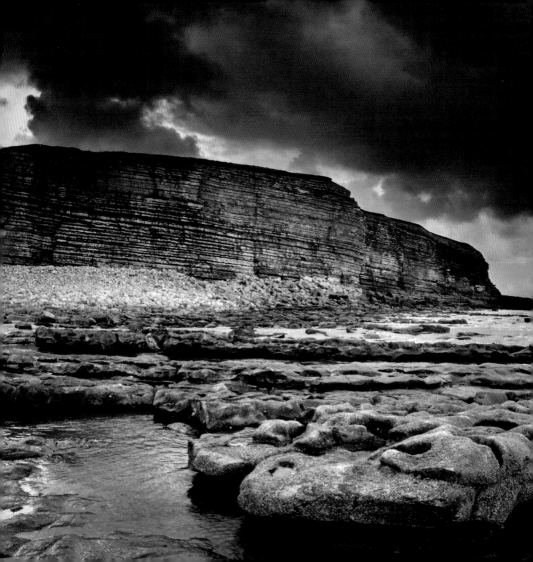

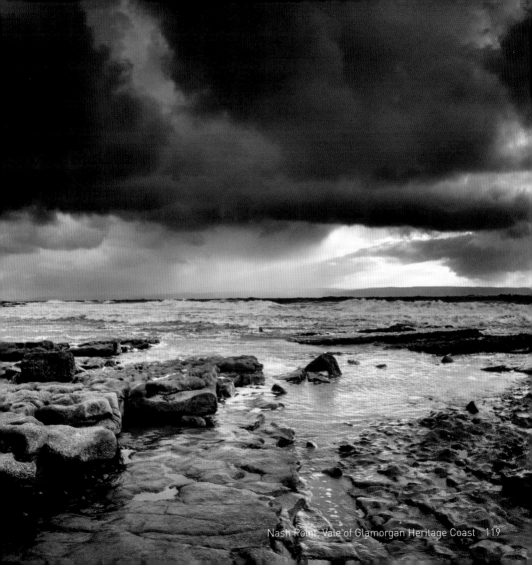

CARDIFF AND CARDIFF BAY

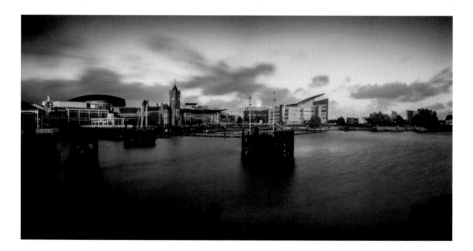

Cardiff has been a city since 1905 and then, fifty years later, became the capital of a resurgent Wales; home of BBC Wales, the National Museum Wales, the National Assembly for Wales and the Welsh Government.

In 2015 Cardiff was voted the UK's most liveable city with a high quality of life and a fine array of international standard cultural and sporting facilities.

Today, the city has a population of 354,000 and sits at the heart of a wider city region serving more than 1.5m. Just two hours from London, it is projected to become the fastest growing city in the UK over the next 20 years with 80,000 new, mostly young, people deciding to live and work in the city, requiring 40,000 new homes and creating a similar number of jobs.

Not content to have one river flowing through it, Cardiff straddles three rivers: the Ely, the Rhymney and the Taff. Cardiff was, however, founded on flat land at an early crossing point of the River Taff, sitting between the Bristol Channel and Caerphilly Mountain to the north. This city – 'the fortress on the Taff' – had humble beginnings as a Roman military base. The remains of the Roman walls were incorporated into the later Norman and Victorian developments of Cardiff Castle. For five hundred years Cardiff remained a modest sized town. However, in the sixty years between the census of 1841 and that of 1901, Cardiff's population grew from 10,000 to over 164,000 as a result

of the need to export 'King Coal' from the south Wales valleys and import the raw materials needed to drive the heavy industrial economy of the region. By 1873 it was referred to for the first time as the 'metropolis of Wales.'

This industrial demand witnessed the creation of the port of Cardiff, an investment led by the Marquess of Bute – its first dry dock opening in 1939. The Glamorganshire Canal, which opened in 1794, was initially able to link the coal-producing valleys to the new docks but this was soon upstaged and replaced with the coming of the railways in the early 1840s. Major investments took place to expand the docks and facilities south of the railway, and this became the fabled Tiger Bay - an area inhabited by sailors and their families from all around the world, as well as by dockworkers.

By the turn of the century the Butes were one of the wealthiest families in the world and Cardiff was the world's biggest coal port, handling 10m tonnes of coal a year. Such was its status that Cardiff's trading floor for coal, the Coal Exchange, achieved worldwide recognition as the place where the price of coal around the globe was set. Up to 10,000 people would pass through its doors each day and, in 1901, it

played host to the world's first one million pound cheque.

Industrial decline and a changing global economy led to the demise of Cardiff's position as a global port. The docks fell into disrepair and they became a redundant wasteland. In 1987 an initiative was established to regenerate this area and, by 2001, a barrage had been built across the mouth of the rivers Ely and Taff to create the 500-acre freshwater Cardiff Bay. This has now become an emblem of the 'new' Cardiff and a focal point for business and leisure investment. The bay hosts many international and national events each year and, in 2018, will host a stage of the Volvo Ocean Race. It is home to the Government's Senedd building, designed by Richard Rogers, and the Wales Millennium Centre. New plans have recently been agreed for the next exciting stage of the development of the bay area.

Today Cardiff is a vibrant, confident, thriving and very contemporary city. It has swept away its industrial image but, with its 2,000 years of history being ever present in its city centre castle and Victorian arcades, the connections with the past are never far away or forgotten. Hidden amongst housing on the west of the city near Caerau is a recently discovered Iron Age Fort – one of the most important archaeological sites in Wales. Nearby in the 'Garden Village'-designed suburb of Ely was a former national hunt racecourse. To the east, in Llanrhymney, is the former home of the famous pirate Harry Morgan (he of the eponymous brand of rum).

To this you could add a very generous helping of parks, great shopping and a thriving collection of bars and restaurants, not forgetting a culturally diverse population with a very warm welcome at its heart.

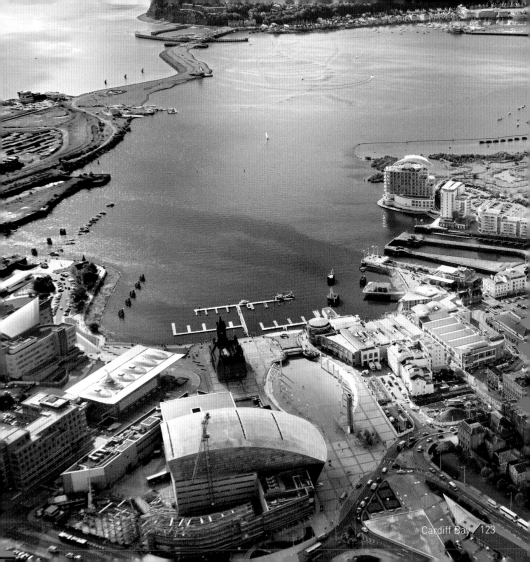

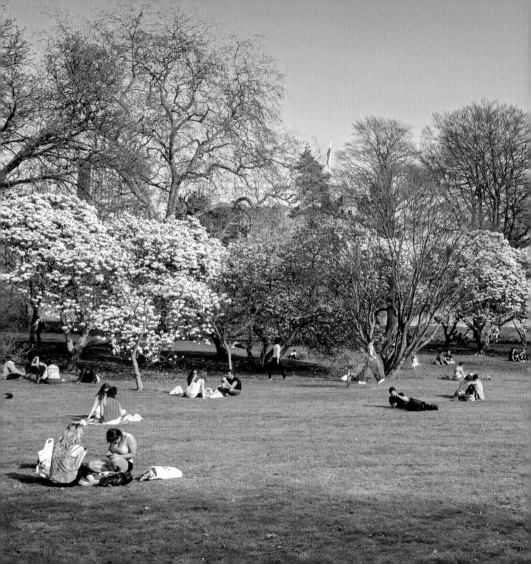

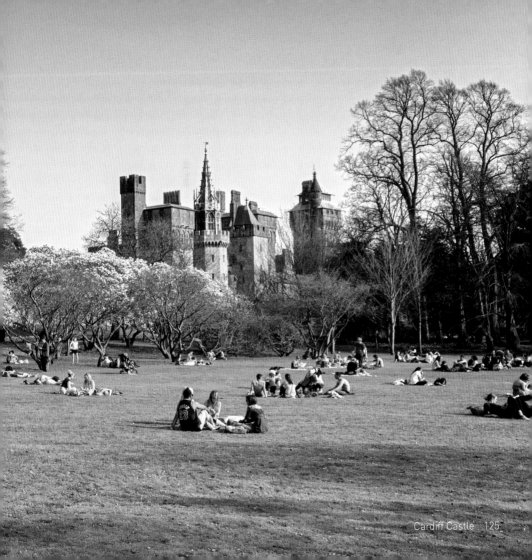

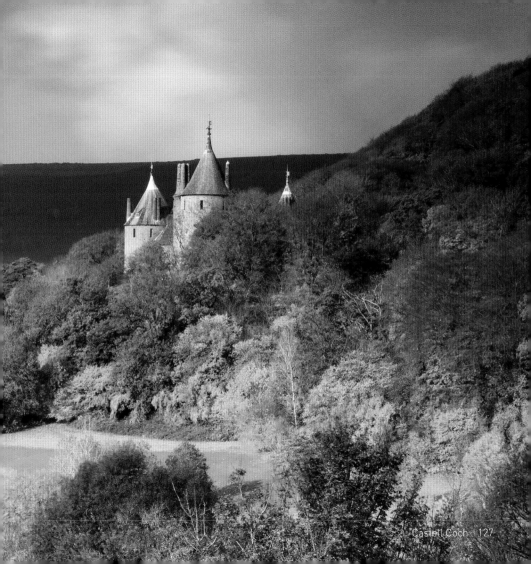

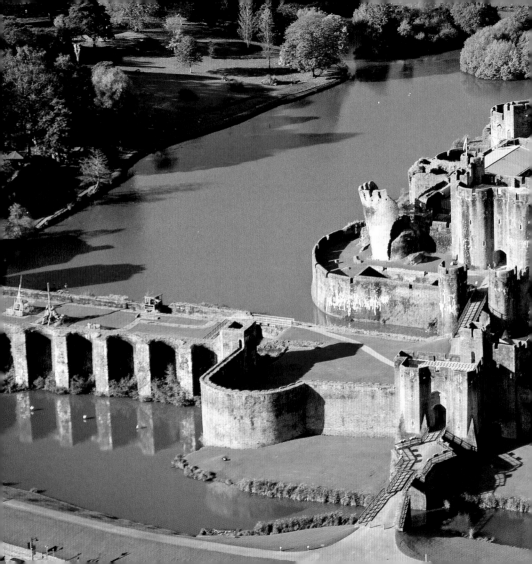

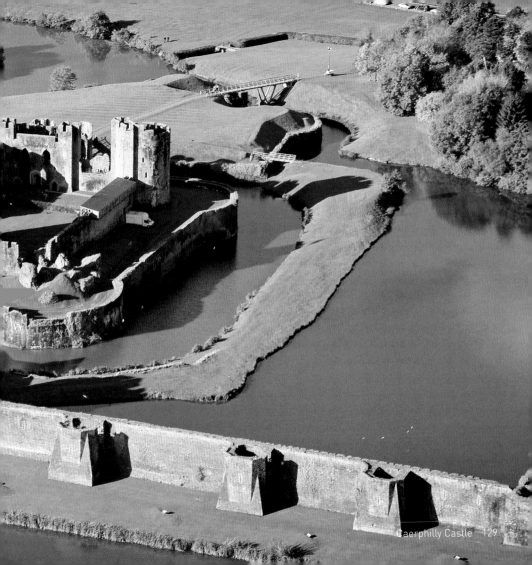

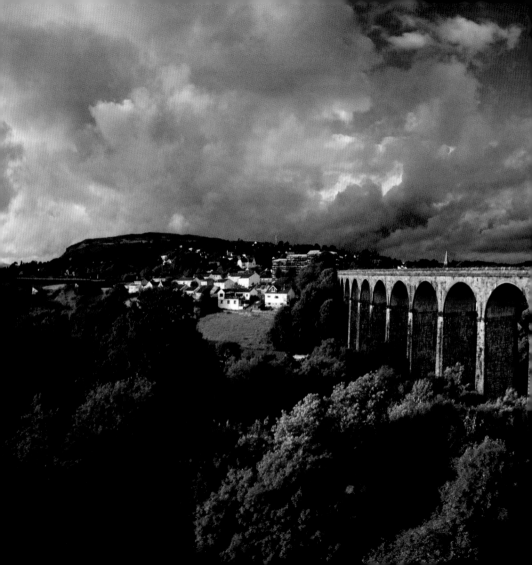

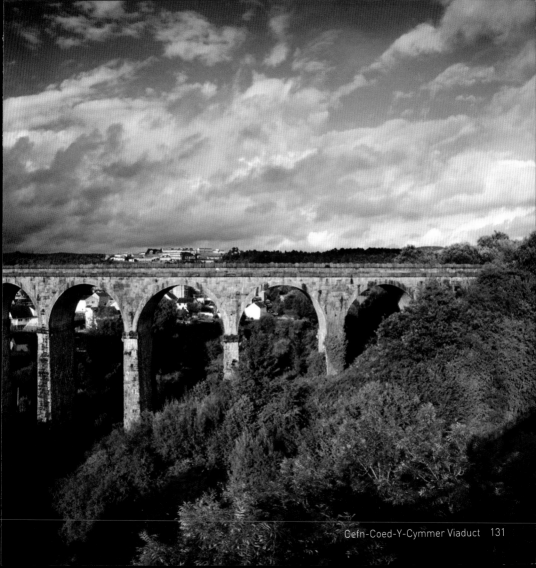

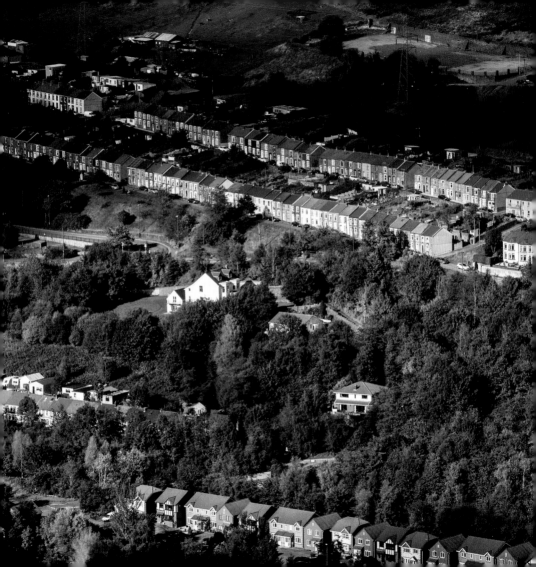

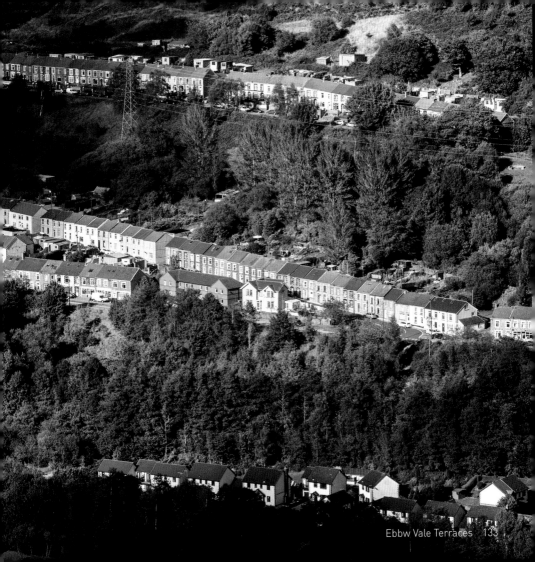

SUGARLOAF MOUNTAIN

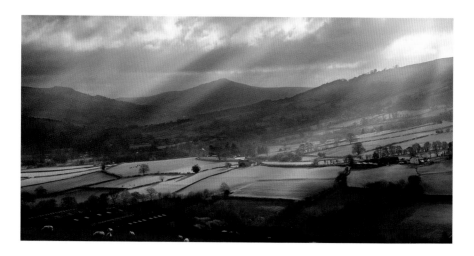

The Sugarloaf Mountain dominates the skyline of the eastern Brecon Beacons National Park at nearly 2,000ft, 596m, high.

To the north and north-east of the historic, walled, market town of Abergavenny are two striking natural features that stand in isolation from the rest of the upland mass.

Ysgyryd Fawr or Skirrid Mountain, the more rugged of the two with its distinctive peak, is an easterly outlier of the Black Mountains, the easternmost range of hills in the Brecon Beacons National Park. With its reputation as a holy mountain, it has long been a popular place of pilgrimage, particularly associated with Michaelmas Eve. It is still a tradition that pocketing a tiny portion of soil from the mountain will bring good luck.

To the north of Abergavenny, and at the heart of the Black Mountains, is the Sugarloaf, Mynydd Pen-y-Fal. The bedrock of the Sugarloaf is Old Red Sandstone which has been shaped by ice, creating its memorable conical summit and deep wooded valleys. On the mountain, a labyrinth of waymarked footpaths and trails take the visitor through a range of landscapes from the wooded St Mary's Vale and Cibi Valley to the open common land of the higher ground. At the point where the oak woodland ends and the ground opens out, the walker can enjoy the spectacle of grand views in every direction en route to the summit.

From its vantage point of almost 1955ft, 596m, the Sugarloaf delivers views of Pen-y-Fan, the high point of the Brecon Beacons to the west; Skirrid and, in the further distance, Gloucestershire's Cotswolds to the east; the UNESCO World Heritage Site of Blaenavon with the Severn Estuary beyond to the south; and to the north the Ewyas Valley with the Hatterrall Ridge.

In the shadow of the Sugerloaf lies the market town of Abergavenny, Y Fenni. Positioned at the confluence of the rivers Usk and Gavenny, it has always been a centre of communication and rural life. It was an important medieval walled town and, prior to that, the Romans established a fort here, recognising its strategic location as gateway to mountain passes into mid-Wales and access to the fertile lands to the south and north. Little of this built heritage remains, however the former Benedictine Priory Church of St. Mary's, known as the Westminster Abbey of Wales, and its newly restored Tithe Barn are buildings of exceptional quality. Abergavenny remains an important market town and its food festival, held each September, is of international renown.

Overlooking the town to the south is Blorenge hill and, sitting above the Clydach Gorge, Coity Mountain. These form part of the UNESCO World Heritage Site of Blaenavon. This landscape was inscribed on UNESCO's list in 2000 because of its importance as bearing 'exceptional testimony to the dynamic forces that drove the Industrial Revolution.' Yet whilst the effects of such forces are indelibly etched into the very fabric of the landscape, it is arguably the raw, bucolic and timeless beauty of the Black Mountains which makes this area truly one not to miss.

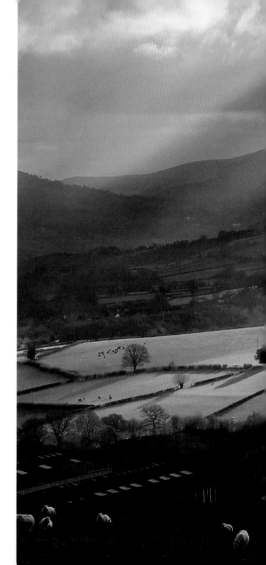

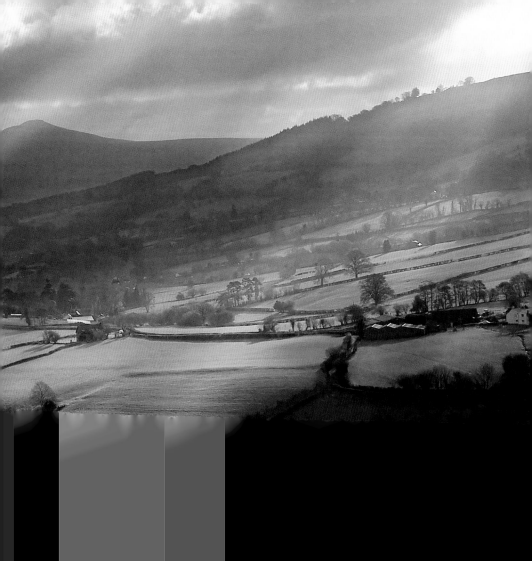

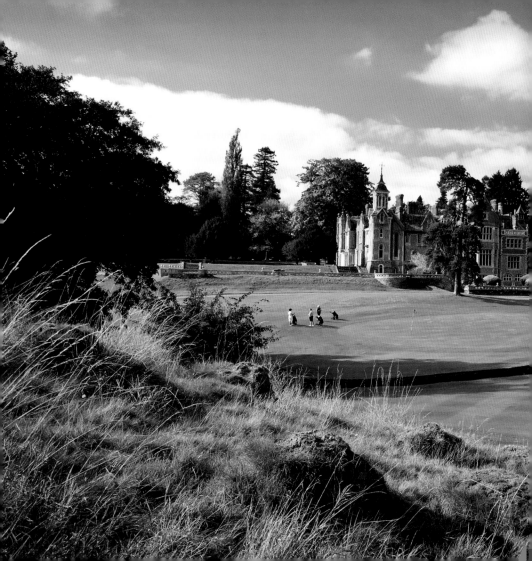

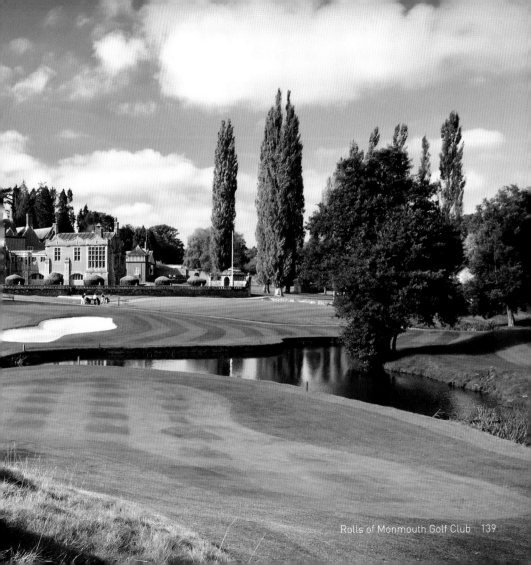

THE WYE VALLEY AND SYMONDS YAT

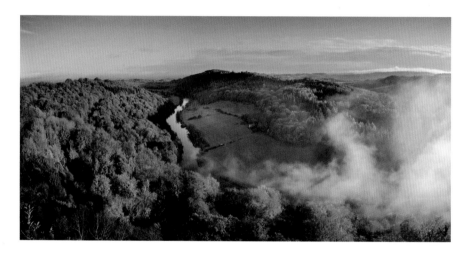

The River Wye, Afon Gwy, is the fifth longest and one of the cleanest rivers in Britain. It is also one of the most beautiful. In his masterful travelogue of 1862, George Borrow described the Wye as 'the most lovely river, probably, the world can boast.'

The Wye weaves a 180-mile journey from the wide-open moors of Plynlimon at 2,468ft in the Cambrian Mountains before disgorging its accumulated waters into the Severn Estuary just below Chepstow's Norman Castle. For centuries, the Wye has been the umbilical cord which joined the rural hinterland of mid-Wales to the industrial communities of the south, making the essential connection out to the wider world.

On this journey the river, a spawning ground for salmon, has also given and nurtured the fortunes of many eponymous market towns and villages whose very existence are intertwined with its flow. There is Hay-on-Wye, with its internationally renowned literature festival, Newbridge-on-Wye, Ross-on-Wye and, at the gateway to the Elan Valey, Rhayader, also known as Rheadr Gwy meaning 'The Waterfall on the Wye.'

Just north of Monmouth, birthplace of Henry V and favoured haunt of Lord Nelson when he was procuring oak for the Royal Navy from The Royal Forest of Dean, and south of Symonds Yat, the Wye loops and bends through a series of gorges described by William Wordsworth as having 'steep woods, lofty cliffs, and a green pastoral landscape.' Overlooking the river are countless crags whose names evoke myth and adventure: Lovers Leap, The Devil's Pulpit, The Eagle's Nest and Yat Rock.

Wordsworth, along with other eighteenth century romantics, was enchanted by the 'prospect' of the beauty of the Lower Wye Valley. Gilpin's 1782 'Observations on the River Wye', together with the writings of the poets Gray, Thackeray, Coleridge and paintings of J.M.W. Turner helped to create a nascent tourism industry for the area 200 years ago, with regular boat tours from Chepstow running upstream beyond the ruined shell of Tintern's Cistercian Abbey which dates from 1131.

Tourism continues as a flourishing year-round activity in this part of the valley. It is a landscape for soft adventure: walking, cycling, canoeing, paddling and horse trekking. Autumnal colours spill over from the Forest of Dean on the English side of the Wye whilst woodland's spring bluebells and the verdant greens in the meadows on the Welsh side give a scenic beauty worthy of its designation as an Area of Outstanding Natural Beauty. A beauty that, in 1967, inspired the famous American 'Beat Poet', Allen Ginsberg to visit the area and pen his neo-romantic poem, 'Wales - Visitation'. Today, it is still a destination that continues to be respected and loved by all with the eye to see and the time to enjoy.

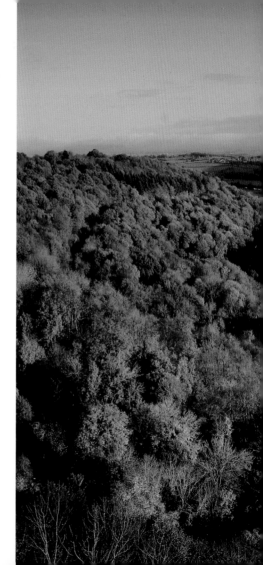

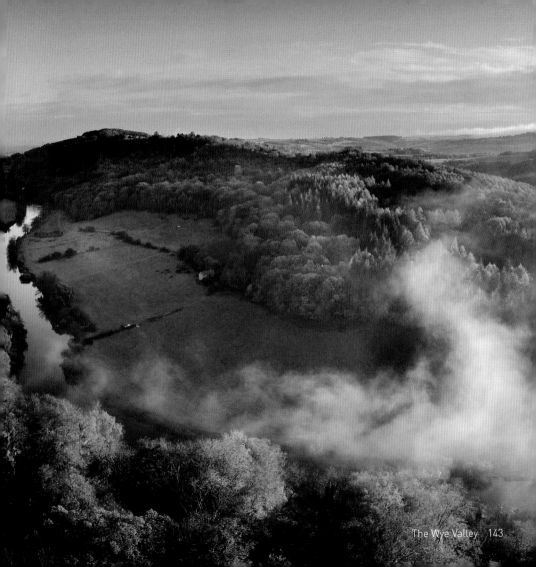

PHOTOGRAPHIC LOCATIONS

N

Key

Kilometres

0	10	20	30	40	50	60

0	10	20	30	40

Miles

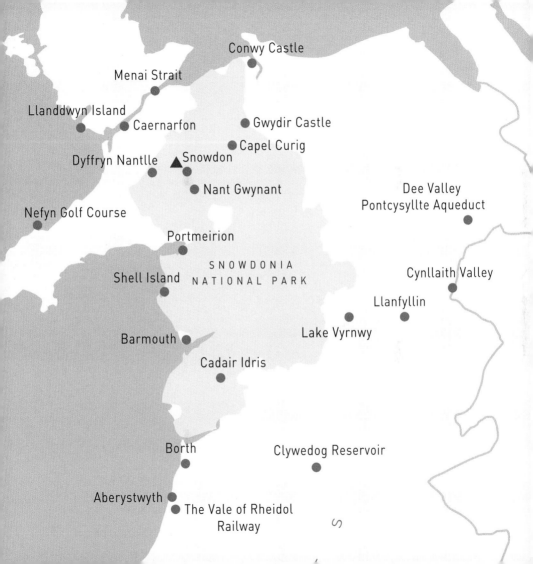

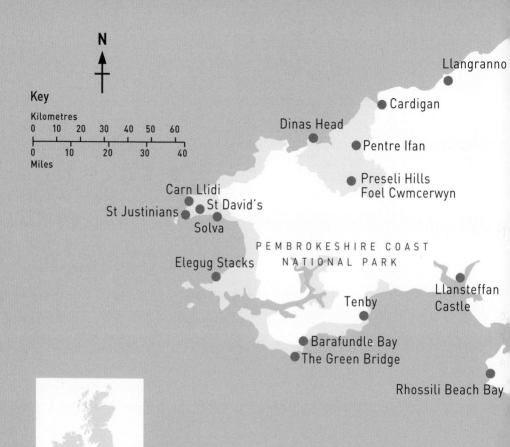

Llangranno

Cardigan

Dinas Head

Pentre Ifan

Preseli Hills
Foel Cwmcerwyn

Carn Llidi

St Justinians

St David's

Solva

Elegug Stacks

PEMBROKESHIRE COAST
NATIONAL PARK

Llansteffan
Castle

Tenby

Barafundle Bay
The Green Bridge

Rhossili Beach Bay

N

Key

Kilometres

0 10 20 30 40 50 60

0 10 20 30 40

Miles

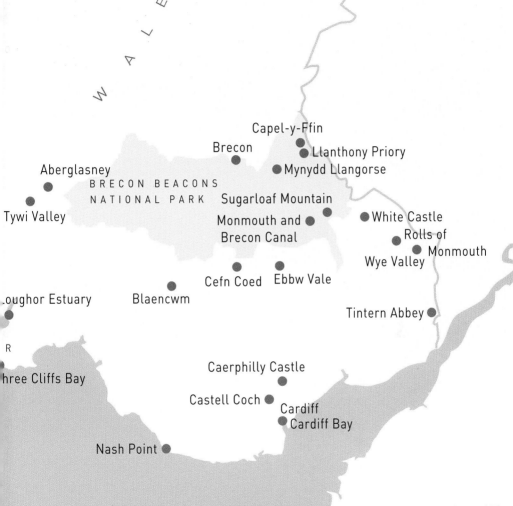

W A L E S

Capel-y-Ffin

Brecon ● Llanthony Priory

Aberglasney
BRECON BEACONS
NATIONAL PARK
● Mynydd Llangorse

Tywi Valley
Sugarloaf Mountain

Monmouth and
Brecon Canal
● White Castle

Rolls of
Monmouth

Wye Valley

Cefn Coed ● Ebbw Vale

oughor Estuary Blaencwm

Tintern Abbey ●

R

hree Cliffs Bay

Caerphilly Castle ●

Castell Coch ●

Cardiff
● Cardiff Bay

Nash Point ●

PICTURE INDEX

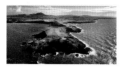

Cover
Nefyn Golf Course, Llyn
Peninsula. Photograph ©
Crown Copyright (2016) Visit
Wales / Harry Williams

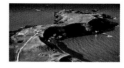

Inside front cover
Nefyn Golf Course, Llyn
Peninsula. Photograph ©
Crown Copyright (2016) Visit
Wales / Harry Williams

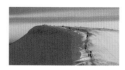

Title page
Pen y Fan, Dawn Awakening.
Photograph © Drew Buckley

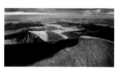

Pages 8-9
Brecon Beacons.
Photograph © Crown Copyright
(2016) Visit Wales / Harry
Williams

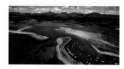

Pages 16-17
Shell Island.
Photograph © Crown Copyright
(2016) Visit Wales / Harry
Williams

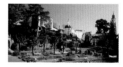

Pages 10, 18
Portmeirion.
Photograph © David Wilson

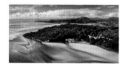

Pages 20-21
Portmeirion.
Photograph © Crown Copyright
(2016) Visit Wales / Harry
Williams

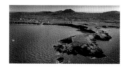

Cover and Pages 4, 22-23
Nefyn Golf Course, Llyn
Peninsula. Photograph ©
Crown Copyright (2016) Visit
Wales / Harry Williams

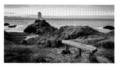

Pages 24-25
Llanddwyn Island, Anglesey.
Photograph © Drew Buckley

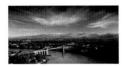

Pages 26-27
Menai Strait.
Photograph © Crown Copyright
(2016) Visit Wales / Harry
Williams

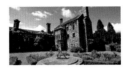

Pages 28-29
Gwydir Castle.
The Photolibrary Wales / Alamy
Stock Photo

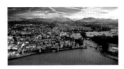

Pages 30-31
Caernarfon.
Photograph © Crown Copyright
(2016) Visit Wales / Harry
Williams

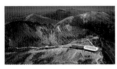

Pages 34-35
Snowdon Summit.
Photograph © Crown Copyright
(2016) Visit Wales / Harry
Williams

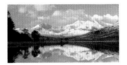

Pages 32, 36-37
Snowdon from Capel Curig.
Photograph © Chris Warren

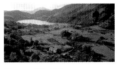

Pages 38-39
Nant Gwynant.
Photograph © Chris Warren

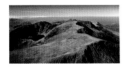

Pages 40-41
Cadair Idris.
Photograph © Crown Copyright
(2016) Visit Wales / Harry
Williams

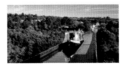

Page 42
Pontcysyllte Aqueduct.
Photograph © Crown
Copyright (2016) Visit Wales /
Harry Williams

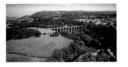

Pages 44-45
Pontcysyllte Aqueduct, Dee
Valley. Photograph © Crown
Copyright (2016) Visit Wales /
Harry Williams

PICTURE INDEX

Pages 48
Sycharth. © Crown copyright: Royal
Commission on the Ancient and
Historical Monuments of Wales |
© Hawlfraint y Goron: Comisiwn
Brenhinol Henebion Cymru.

Pages 50-51
Lake Vyrnwy.
Photograph © Harry Williams

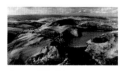

Pages 52-53
Clywedog Reservoir.
Photograph © Crown Copyright
(2016) Visit Wales / Harry
Williams

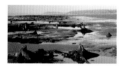

Page 54
Borth and Cardigan Bay.
Photograph © Janet Baxter

Pages 56-57
Barmouth, Mawddach
Estuary. Photograph © Crown
Copyright (2016) Visit Wales /
Harry Williams

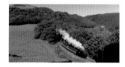

Pages 58-59
Vale of Rheidol Railway.
Photograph © Janet Baxter

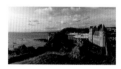

Pages 60-61
Aberystwyth.
Photograph © Janet Baxter

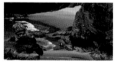

Pages 62-63
Cilborth, Llangranog.
Photograph © Crown
Copyright (2016) Visit Wales /
Harry Williams

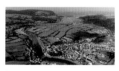

Pages 64-65
Cardigan.
Photograph © Janet Baxter

Page 66
Capel-y-Ffin.
robertharding / Alamy Stock
Photo

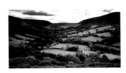

Pages 68-69
Castle Farm, Black
Mountains.
Photograph © Chris Geary

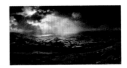

Pages 70-71
Mynydd Llangorse.
Photograph © Nigel Forster

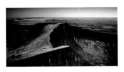

Pages 72-73
Brecon Beacons.
Photograph © Crown Copyright
(2016) Visit Wales / Harry
Williams

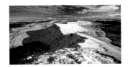

Pages 74-75
Brecon Beacons.
Photograph © Nigel Forster

Pages 76-77
Monmouth and Brecon
Canal. Photograph © Crown
Copyright (2016) Visit Wales /
Harry Williams

Pages 78-79
Brecon.
Photograph © Dan Santillo

Pages 82, 84-85
Foel Cwmcerwyn.
Photograph © Drew Buckley

Pages 86-87
Preseli Hills.
Photograph © Nigel Forster

PICTURE INDEX

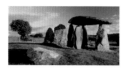

Pages 88-89
Pentre Ifan.
Photograph © Janet Baxter

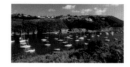

Pages 90-91
Solva.
Photograph © Janet Baxter

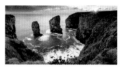

Pages 92-93
Elegug Stacks.
Photograph © Drew Buckley

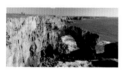

Pages 94-95
The Green Bridge of Wales.
Photograph © Janet Baxter

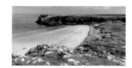

Pages 96-97
Barafundle Bay.
Photograph © Drew Buckley

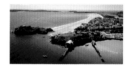

Pages 98-99
Tenby.
Photograph © Crown Copyright
(2016) Visit Wales / Harry
Williams

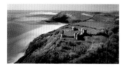

Pages 100-101
Llansteffan Castle.
Photograph © Crown Copyright
(2016) Visit Wales / Harry
Williams

Pages 102, 104-105
Loughor Estuary.
Photograph © Graham Smith

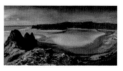

Pages 106-107
Three Cliffs Bay.
Photograph © Nigel Forster

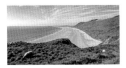

Pages 108-109
Rhossili Bay Beach.
Photograph © Crown Copyright
(2016) Visit Wales

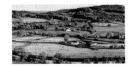

Pages 110, 112-113
Towy Valley near Dinefwr.
Photograph © Drew Buckley

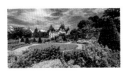

Pages 114-116
Aberglasney Gardens.
Photograph © Crown Copyright
(2016) Visit Wales / Harry
Williams

Pages 118-119
Nash Point, Vale of
Glamorgan Heritage Coast.
Photograph © Nigel Forster

Page 120
Cardiff Bay.
Photograph © Nigel Forster

Pages 123
Cardiff Bay.
Photograph © Crown Copyright
(2016) Visit Wales

Pages 124-125
Cardiff Castle.
Photograph © Crown Copyright
(2016) Visit Wales

Pages 126-127
Castell Coch.
Photograph © Billy Stock

Pages 128-129
Caerphilly Castle.
Photograph © Crown Copyright
(2016) Visit Wales / Harry
Williams

PICTURE INDEX

Pages 130-131
Cefn-coed-y-cymmer
viaduct.
Photograph © Nigel Forster

Pages 132-133
Ebbw Vale terraces.
Photograph © Nigel Forster

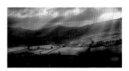

Pages 134, 136-137
Sugarloaf Mountain.
Photograph © Nigel Forster

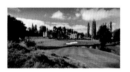

Pages 138-139
Rolls of Monmouth Golf Club.
Photograph © Harry Williams

Pages 140, 142-143
The Wye Valley.
Photograph © Nigel Forster

TERRY STEVENS

Professor Terry Stevens is an international tourism consultant. A love of travel and interest in landscape was inspired by a teacher of geography at Yeovil Grammar School and fuelled by fellow East Coker 'villagers'; William Dampier (1651 – 1715) explorer, hydrographer and buccaneer; and the great twentieth-century poet, T. S. Eliot.

Terry arrived in Swansea to study Geography at Swansea University in 1970. After gaining his MSc in Land Management at Reading University he returned to work at the Wales Tourist Board and has lived in Wales ever since, where he learnt to speak Welsh. After working as the Director of Tourism for West Glamorgan Council, Terry became Development Manager for Cadw: Welsh Historic Monuments and later Dean and Professor of Tourism Management at Swansea Metropolitan University before establishing his consultancy business. Today he spends his time running his business advising on tourism development around the world alongside being Professor of Strategic Communications at the School of Management at Swansea University and enjoying time with his family, especially his three grandsons – Jac, Elis and Gruff to whom this book is dedicated.

PHOTOGRAPHERS

Billy Stock

Trading as a professional photographer since 1990, and acquiring a wide range of photographic experience on, landscapes, architecture, and commercial, Billy's images have been published worldwide in books, calendars and more. billystock.co.uk

Chris Geary

Chris Geary is a wedding and landscape photographer from west Berkshire. He has loved photography since he was a child. Capturing beautiful moments and images is his passion.

Chris Warren

Always enjoying the diversity of Wales, whether it's countryside or coastline; over the past 35 years Chris has covered many aspects of Wales during Wales Tourist Board or National Park commissions. chriswarren-uk.com

Dan Santillo

Dan Santillo is a professional photographer based in Swansea, south Wales, specialising in landscape photography and astrophotography of Gower and the Brecon Beacons National Park. DanSantillo.com

David Wilson

David Wilson is a Pembrokeshire-based photographer best known for his atmospheric black and white images. He has published two photography collections with Graffeg, *Pembrokeshire* and *Wales: A Photographer's Journey*. davidwilsonphotography.co.uk

Drew Buckley

Drew Buckley is an award winning Pembrokeshire-based landscape and wildlife photographer. Drew has published two books with Graffeg, *Puffins* and *Wilder Wales*, along with several popular calendars. drewbuckleyphotography.com

Graham Smith

A London commercial photographer by trade, Graham relocated to the Gower, Swansea and enjoys the freedom to create imagery he loves, alongside commissioned work in London and the South West. allabouttheimage.co.uk

Harry Williams

Harry Williams has photographed Wales over the last 40 years and is passionate about the diversity and beauty of its landscape. *Hen Wlad fy nhadau – Land of my fathers*. hwphotography.co.uk

Janet Baxter

Janet Baxter is a photographer based near Aberystwyth in mid Wales, specialising in wildlife, seascapes and landscapes of Wales. janetbaxterphotography.co.uk

Nigel Forster

Nigel Forster is a landscape photographer based in the Brecon Beacons and an experienced tutor in photography to groups and individuals at locations throughout Wales. His work can be seen at creativephotographywales.com

Visit Wales

Wales On View is a non-commercial photographic resource, provided by Visit Wales, the tourism division of Welsh Government. We have an extensive collection of high quality photographic imagery to assist international tourism partners and agencies in promoting the best Wales has to offer. www.walesonview.com

Landscape Wales

Graffeg will continue to search and source spectacular images of Wales for future editions of this book and other publications about the country. graffeg.com

USEFUL CONTACTS

Whether you are looking for historic buildings to visit or stay in; information on Wales' many nature reserves and national parks; or a list of fun things to see and do when you are here, you'll find it below.

Visit Wales

The tourism department of the Welsh Government. For things to do, places to visit, what's on, and where to stay in Wales.
www.visitwales.com
info@visitwales.com
+44 (0)333 006 3001

CADW

For information about castles, events and heritage sites throughout Wales.
cadw.gov.wales
cadw@wales.gsi.gov.uk
+44 (0)1443 336000

Royal Commission on the Ancient and Historical Monuments of Wales

For information on the ancient and historical monuments of Wales.
www.rcahmw.gov.uk
nmr.wales@rcahmw.gov.uk
+44 (0)1970 621200

Tourist Information Centres

Local information about places to eat, shop, where to stay, local events and things to do for kids.
www.visitwales.com/contact/tourist-information-centre

Brecon Beacons National Park

For things to do, places to see and where to stay in the Brecon Beacons.
www.beacons-npa.gov.uk
+44 (0)1874 624437

Snowdonia National Park

For things to do, places to see and where to stay in Snowdonia.
www.eryri-npa.gov.uk
parc@eryri-npa.gov.uk
+44 (0)1766 770274

Pembrokeshire National Park

For things to do, places to see and where to stay in Pembrokeshire.
www.pembrokeshirecoast.org.uk
info@pembrokeshirecoast.org.uk
+44 (0)1646 624800

National Trust

For information on visiting over 350 historic houses, gardens and ancient mountains, along with forests, woods, moorland, farmland, islands and more.
www.nationaltrust.org.uk
enquiries@nationaltrust.org.uk
+44 (0)344 800 1895

RSPB

A charity working to secure a healthy environment for birds and all wildlife.
www.rspb.org.uk
birdwatch@rspb.org.uk
+44(0)1767 680551

Landmark Trust

For holidays in historic buildings.
bookings@landmarktrust.org.uk
+44 (0)1628 825925

Natural Resources Wales

A Welsh Government sponsored body that works to protect people and the environment in Wales.
www.naturalresources.wales
enquiries@naturalresourceswales.gov.uk
+44 (0)300 065 3000

Visit Britain

For places to go, things to do and where to stay when in Britain.
www.visitbritain.com

GRAFFEG

Graffeg was formed in 2001 by designer Peter Gill and photographer Steve Benbow with the aim of publishing outstanding illustrated books about Wales; books that inform, entertain, inspire and take people to places they know and love. Today Graffeg is a growing independent publisher, producing beautiful books and merchandise with some great authors, illustrators, photographers, designers and editors.

Nothing has changed about the basics of publishing – it's still about words and pictures. Producing inspiring illustrated books is about working with outstanding creative talents. Finding the right image means finding dedicated and clever photographers capable of capturing spectacular pictures. That includes the photographers who will wake at 3am, carry bags of equipment in the dark, scramble to the top of a mountain and wait for sunrise just to capture the perfect breath-taking photograph. We hope this book will show everyone who looks through these pages that Wales has some spectacular views and some pretty amazing photographers too.

www.graffeg.com
croeso@graffeg.com

Landscape Wales

- Author Terry Stevens
- Hardback 192 pages
- Size 300 x 300mm
- ISBN 9781909823464

Landscape Wales Notecards

- 10 Landscape Wales cards with envelopes for any occasion
- Blank inside for message or greeting
- Card size 160 × 120mm

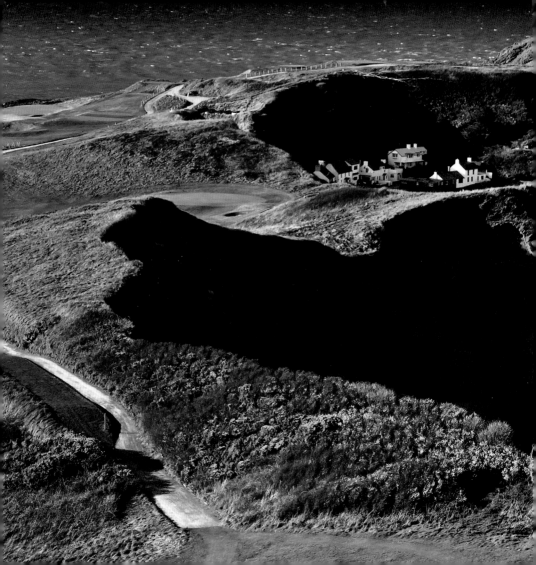